el

30x

John Raimondi: Sculptor

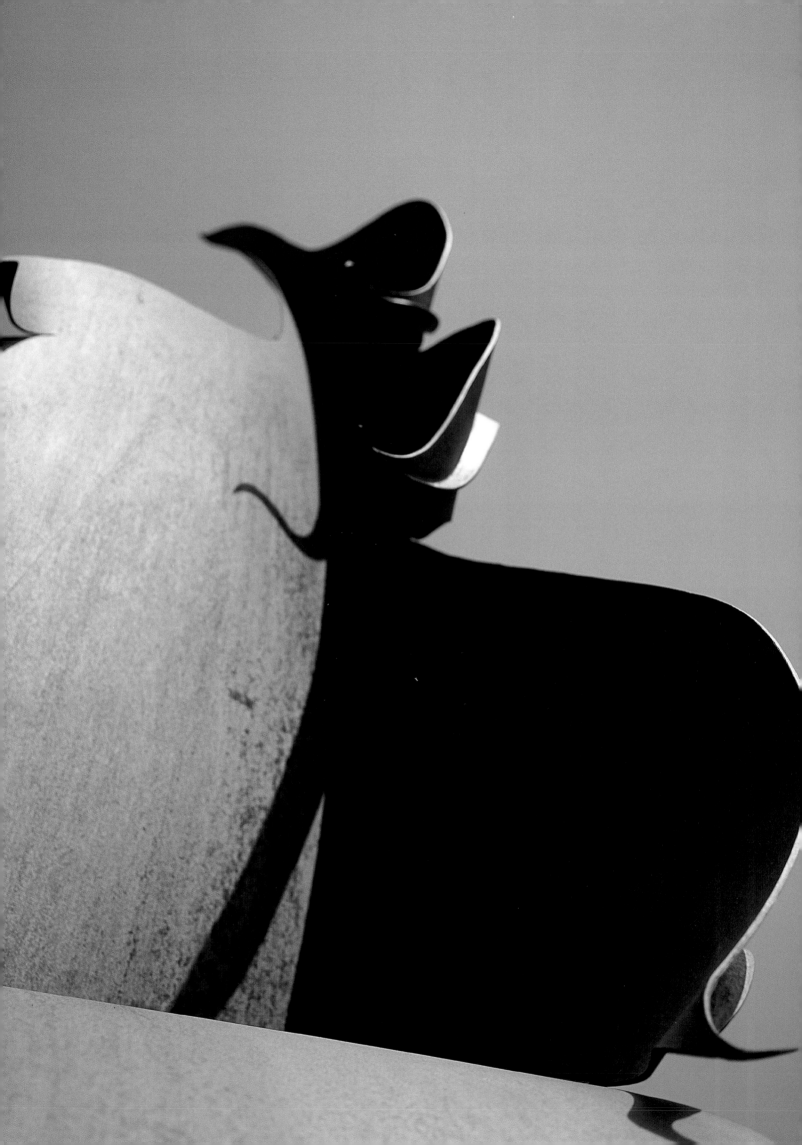

John Raimondi: Sculptor

Sam Hunter

William Corbett

Hudson Hills Press, New York

First Edition

"Raimondi's Space Probes" © 1999 by Sam Hunter.
"John Raimondi, Sculptor of Monuments" © 1999 by William Corbett.
Illustrations © 1999 by John Raimondi.

Published in the United States by Hudson Hills Press, Inc.,
122 East 25th Street, 5th Floor, New York, NY 10010-2936.

Distributed in the United States, its territories and possessions,
and Canada by National Book Network.
Distributed in the United Kingdom, Eire, and Europe by
Art Books International Ltd.

Editor and Publisher: Paul Anbinder
Manuscript Editor: Fronia W. Simpson
Proofreader: Lydia Edwards
Indexer: Karla J. Knight
Design and Composition: Glenn Suokko
Manufactured in Japan by Dai Nippon Printing Co.

Library of Congress Cataloguing-in-Publication Data
Hunter, Sam, 1923–
 John Raimondi : sculptor / Sam Hunter, William Corbett.
 — 1st ed.
 p. cm.
 Includes bibliographical references.
 ISBN 1-55595-179-1 (cloth : alk. paper)
 1. Raimondi, John, 1948– Catalogues.
 I. Raimondi, John, 1948– .
 II. Corbett, William, 1942– . III. Title.
 N6537.R234A4 1999
 730'.92—dc21 99-16550
 CIP

frontispiece:

Lupus (detail), 1985
Cor-ten steel, 40' tall x 8' x 7'
Lotus Development Corp., Cambridge, Massachusetts

Contents

Dedication

For my parents, Peter and Erma Raimondi;
Ralph T. Cantin, the love of my life;
and Max and Cil Draime.

J.R.

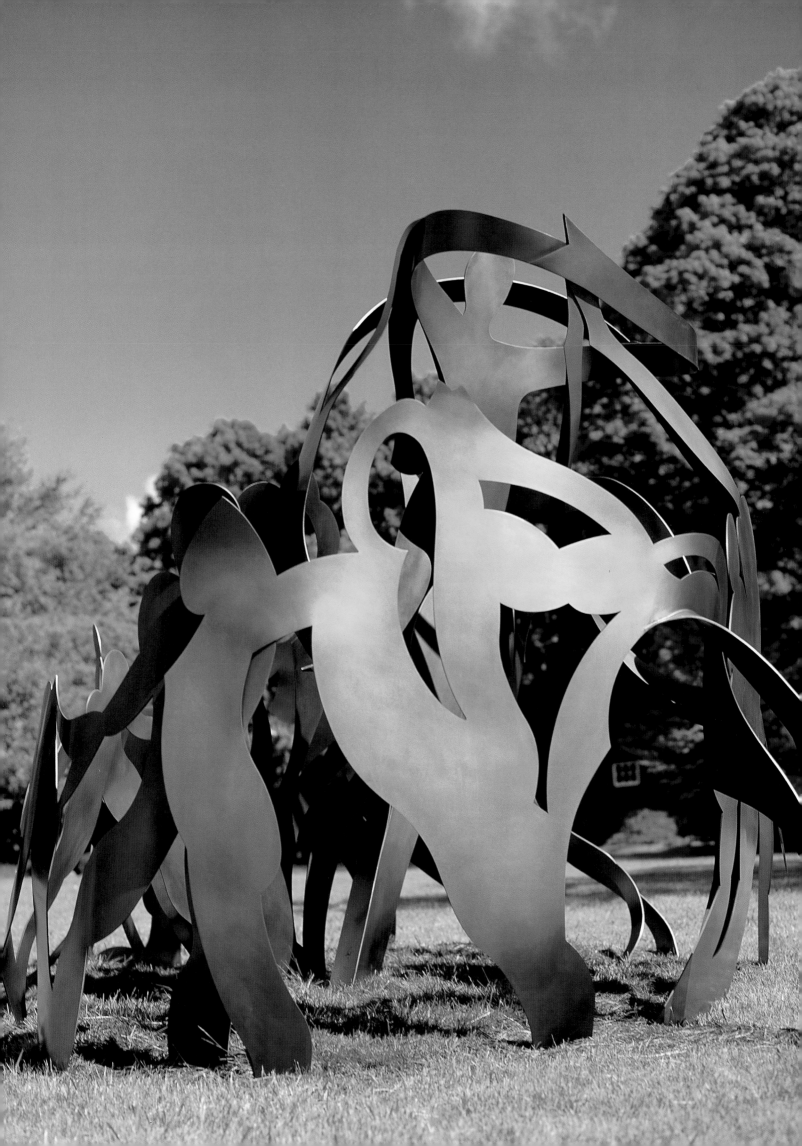

Raimondi's Space Probes

Wherever they may be, John Raimondi's dramatic monumental sculptures stand alone and strikingly apart from the everyday world.

Artorius (1989), the forty-one-foot-high Cor-ten stele that rises above the grounds of Stockley Park, Heathrow, in London, is at once a delicate yet overwhelming statement. Resembling the great *Endless Column* of Brancusi, at Tirgu Jui in Romania, with its elevation and powerful extension, it also suggests an attenuated gladiator or, in keeping with its location, even an Arthurian knight holding aloft the sword Excalibur; despite its formal rigor, it intentionally emphasizes form and myth equally.

Similarly, Raimondi's 1985 Cor-ten composition, *Lupus,* rising forty feet above its Cambridge, Massachusetts, site, mixes Jungian memory and a desire to spring free of the earth. Here, however, the twisting motif is more primal and also more baroque stylistically in its intertwined elements. Swirling to a sharp, feral spike from its looping layers of velvety, rusty steel skin, *Lupus* expresses the spirit of baying wolves even as it breaks the Boston skyline and anchors the eye. Its slashing forms and tilting planes render gravity weightless, and the emphatic planes also convey something of the heroic emotional impact of Abstract Expressionism, and of Franz Kline's broad brush and canted forms in particular, which have often been identified as an influence in Mark di Suvero's monumental outdoor sculpture. In turn, Di Suvero set an important precedent in the 1960s by enlarging his work on public sites to architectural scale.

From such early examples as the twenty-foot-high *David* of 1972 to a recent masterwork, entitled *Journeys,* a lacy loop of flattened bronze configurations assembled in 1997, Raimondi has explored a productive path of sculptural logic in a single-minded fashion; essentially he has focused, but with a difference, on a strict, impersonal formalism. Designed to be perceived initially from a distance, in the tradition of the ornamented Roman arch, column, or colossal portrait, or, indeed, the classicizing architectural symbols of government in Washington, D.C., his large-scale sculptural icons also take advantage of contemporary technology and the availability of advanced alloys of bronze and TIG-welding. These new sculptural means, which provide a particularly strong method of bonding one sheet of metal to another, have given him new kinds of experimental and conceptual freedom.

In addition, Raimondi has become profoundly involved with color, a long-neglected aspect of contemporary, large-scale sculpture. His unusual finishes and richly chromatic, lustrous, and textured surfaces contribute strongly to the force of visual statements that are at once lithe and muscular. His color experiments have, indeed, redefined his modernism. He has enhanced the finishes possible with bronze, taking a leaf from Archipenko's book, says Raimondi, the New England artist who about a decade ago pulled up stakes and shifted his base of operations from the Boston area to Palm Beach, Florida.

Raimondi admires Archipenko "tremendously," he has remarked. "He wasn't afraid of doing a bright blue patina or a flat jet black, a dense green or, for that matter, a vivid red patina. He used bronze in the fullest possible way." Certainly, Raimondi says, Archipenko was operating within the strictures of his era, casting bronze and working of necessity on a more intimate scale outdoors than is considered appropriate today. "There was no such thing

Journeys, 1997
Bronze, 9' tall x 14'6" x 10'5"
Private Collection, Connecticut

then as bronze fabricating. I think Archipenko was the first to say that sculpture can be colorful, and he was the first to use color in sculpture—concave, convex, and all of those things that he was really involved in." "I admire his surfaces as much as his textures when he was doing things like his Egyptian figures and his flat torsos of 1914 or 1916, when he did *Ra,* a piece that came before Brancusi's *Bird in Space,*" Raimondi has observed.[1] Acutely aware of his precedents, the sculptor has progressed over the past three decades from smaller, earth-bound forms in steel to figures that are ever more complex, ever grander, and ever more engaged in unpredictable, lively interactions with broader and bolder contexts, whether these be environmental, psychological, or philosophical.

His passage has been exciting to track. Raimondi began working as a two-dimensional artist, making illustrations in high school and planning to become a marine painter. By 1969 he had painted *My Sandals,* with its unabashedly old-master style and heavy chiaroscuro, his facility richly apparent. Somber shadows fall across the simple subject, creating a mood not unlike that found in the reflective, multilayered early baroque genre scenes and still lifes of Georges de la Tour and Sanchez Cotan.

He studied at the Portland School of Fine and Applied Arts in Maine, where he was introduced to a concept that already played an intuitive, substantial role in his work: three-dimensional design. "I used to draw very realistically, very hard, and the teacher, Norman Therrien, saw the drawings and said, . . . 'You should get into three-dimensional design, I mean you should really get into that because you're drawing illusionistically; you have a great sense of depth.' "[2]

Urged on by this mentor who was himself a sculptor, Raimondi became aware of novel and thrilling aesthetic possibilities. He began to spend much of his time in Therrien's studio, at his teacher's invitation, working at night and gradually growing adept with Thierrien's own chisels and other traditional equipment generously entrusted to him. To these sculptural tools he adapted naturally. He also began reading extensively, seeking on his own the ideas that would advance him on his new path, and continued his formal education at Massachusetts College of Art in Boston. Again key instructors urged him "to push and probe," confirming a powerful instinctive drive both to define himself through art and to succeed professionally, Raimondi recently recalled.

"I did stuff that looked like Arp. It was all organic and very cutesy—coffee table stuff and very figurative. Then I realized that I was prepared to dedicate my life to art and not to decoration and not to imitation, so I stopped working entirely and all I did was to look and study a lot more; I was determined that I could deal in my own form language, even at an early age."[3]

In short order Raimondi was launched on his unusually clear, self-determined course. He has constantly reached out, increasing his knowledge of art and his chosen artistic precedents and gaining the sophistication to cope with the mundane world. His sense that art and life should be integrated moved him to investigate areas as varied as the environment, endangered species, indigenous peoples, and the elusive, barely tangible nexus he perceived to exist between the visceral and the spiritual in art. That elusive tension is everywhere in his work, even in the early, relatively stolid forms of *David* (1972) and the

equally large-scale, but perhaps more ethereal *JAT* (1973); each sculpture bears striated edges or corrugated markings resembling a roughened tooth-comb on a grand scale. Despite their massiveness and apparent rooted stability, the sculptures' broken edges create an interesting counterforce and an air of unpredictability. Raimondi's consciousness of instability in formal terms seems to translate as an important human constant as well.

Erma's Desire, the multifaceted piece he constructed in 1976 for a site on Grand Island, Nebraska, further emphasized certain ineffable qualities. Inspired by memories of his family, particularly by the mother whose single-minded desire was to raise a son, the bicentennial commission grew from the sort of "gestation period" that would mark each of his typically herculean pieces. Like other works from the 1970s, *Erma's Desire* is "highly geometric, hard-edged," Raimondi remarked in the course of a revealing, hour-long special program produced for Nebraska Public TV. Most of his earlier works constructed before the great airport commission were dedicated to family members and close friends, but since the late eighties his compositions have become more impersonal public ciphers, and they "evolved to embrace fluid, organic forms."[4]

The shift in style, scale, and materials has been striking and increasingly masterful. *Zephyrus* (1980), the powerful Cor-ten form that rises to nine feet and extends a staggering twenty-two feet wide on its Nantucket, Massachusetts, site, resembles both an organic creature, perhaps a giant insect that has lightly landed on the sand, just for the moment, and the rusticated bones of a prehistoric life-form eroded to a mere haunting, if talismanic, memory.

Raimondi installed the abstraction *Aquila* on a Miami site, at NationsBank for the Lincoln Property Company in 1986, and it marks another, even more dramatic step forward for him. Far larger than even his most ambitious preceding work, standing thirty-eight feet high and seventy-eight feet wide, the sweeping forms evoke not so much the appearance as the essence of an eagle. Here he departed for the first time from his customary medium of Cor-ten steel in executing his more important large-scale pieces, choosing instead the more malleable, classical, and variable bronze, which continues to fascinate him today. Structurally and chromatically, bronze seems to offer him more expressive and imaginative opportunities. Unlike *Dance of the Cranes* and more recent, even larger visual statements that require the presence of a team of fabricators, *Aquila* reflects in its process the artist's desire for a hands-on connection to his work, at every stage and on every level.

Nonetheless, the sculpture, whose name is Latin for "eagle" and thus subliminally draws on antique sources, crystallized his primary concerns: to create a great, all-enveloping sculptural presence with mythic overtones that speak in Jungian terms to an infinite multitude of viewers, utilizing materials and techniques that continually push his boundaries. At the same time, he continues to engage ever-changing links between the natural and man-made environments. "To soar like the eagle may not be within our power," Rose Art Museum director Carl Belz noted in his brief but eloquent catalogue foreword on *Aquila*. "We know the kinesthetic sensation nonetheless,

and that sensation is in this instance dramatically heightened by the sculpture's placement before sea and sky, before vast and immeasurable spaces that impel our thoughts toward freedom."[5]

Dance of the Cranes (1988) is a defiantly vertical piece that also swoops from side to side in gestures that capture the wildness and freedom of Nebraska's fabled but omnipresent sandhill cranes. Here Raimondi not only explored his developing interests in chromatic surfaces but learned to manage and direct a team of factory technicians in a demanding public work that had to be welded in place on its site, and then ground down by the team he scrupulously oversaw at Lippincott's North Haven, Connecticut, foundry, to encase it in a sturdy bronze armature.

To settle on the work's final, clean-lined, and deceptively simple form, the artist studied the subject he had first noticed during trips to Nebraska in the seventies, while working on *Erma's Desire*. He read everything from scientific treatises to Oriental folklore, visited Harvard's Museum of Comparative Zoology to study crane anatomy, studied live cranes in captivity and—over a long, steady period—produced a series of drawings and paintings whose delicacy echoes that of the birds themselves. He wanted to show "the fragility and beauty of the animal," he explained in his public television special, groping for words to express what he captures spontaneously with artists' materials. "It's more a poem than a superstructure."[6]

Indeed, though the purpose of the crane's dance—a series of movements both awkward and remarkably assured and affecting—is to mate, it became much more for Raimondi. "Sometimes they dance just to dance," he said, pointing out a key ink-wash sketch that led directly to the soaring structure. "I'm a big romantic about nature, so I called it *Kissing Cranes*. It became just a matter of me allowing the time to let the form develop."[7]

And, for Raimondi, once the form emerges, but only after a protracted period of exploration and probing that has its roots in his earliest three-dimensional forays, he can then make his way to the final, balanced ensemble that imposes itself on viewers from great vistas, gradually changing shape and developing depth as it comes into focus. It is all part and parcel of the aesthetic approach and mixed motivation of an artist who, even as he carries out commissions on the most inspired, heroic scale, makes a sincere effort to be pragmatic about his work and accommodate individual clients or the community, perceiving himself, in his own words, as a sort of art-world maverick.

His more recent works range from the shimmering, stainless-steel *Grace* of 1990 to the swooping, visceral bronze *Ceres* of 1994 to the complex, multidimensional *Journeys* of 1997. These diverse forms convey a unifying fascination with medium and process across a wide band of expressive variations. At the same time, even as they reveal Raimondi's sensitivity to the balance of his formal elements, they also underscore his exquisitely calibrated awareness of scale and his mediumistic, profound link to outside forces, to elements only indirectly apprehended in the work that nonetheless make their presence felt.

As he declared, almost haltingly, when explaining his seminal work, *Dance of the Cranes*, he sought to capture the "nobility of the beast in flight. That's inspiring—we can't do that. It's really spiritual . . . it's really free."[8] In

quite another but surely related context, the sculptor David Smith once protested vigorously against the "monolithic limit in the tradition of sculpture," arguing that sculpture "is as free as the mind," a sentiment Raimondi would undoubtedly endorse.[9]

Notes

1. Harry Rand, "Notes and Conversation: John Raimondi," *ARTS Magazine* (April 1983): 116.

2. Ibid., 111.

3. Ibid.

4. *Dance of the Cranes,* videotape of the 1988 program aired on Nebraska's Public Television network, WPTV. The program was designed primarily to commemorate the $460,000 commission Raimondi completed in 1988 for Omaha's newly remodeled Eppley Airport.

5. Carl Belz, introduction to *Aquila,* exh. cat. (Miami: Barnett Tower Gallery, 1987).

6. *Dance of the Cranes.*

7. Ibid.

8. Ibid.

9. David Smith, quoted in Cleve Gray, ed., *David Smith by David Smith: Sculpture and Writings* (London, Thames and Hudson, 1968), p. 6.

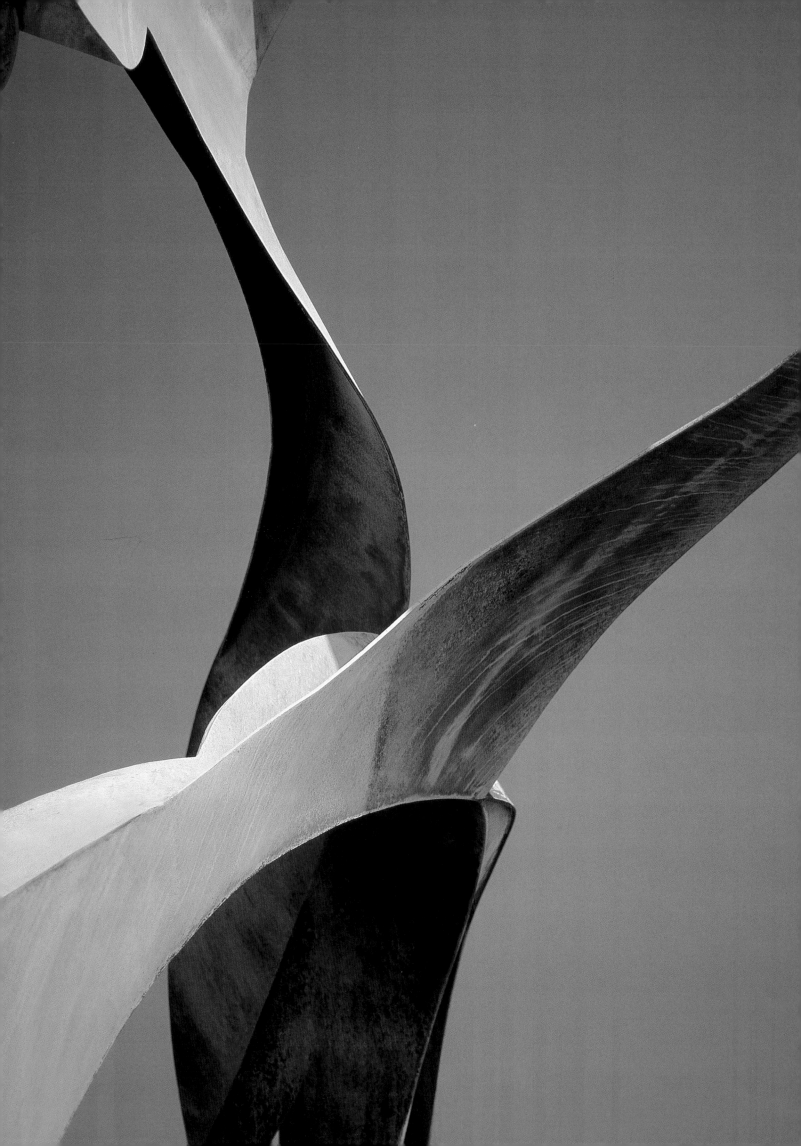

WILLIAM CORBETT

John Raimondi, Sculptor of Monuments

When John Raimondi was a twenty-year-old art school student, so young he knew no fear, he became a monumental sculptor. This form of art demands that the individual be a visionary with the skills of a craftsman, accountant, engineer, and construction foreman. It also requires a salesman's instinct and a savvy for public relations: for in the time between designing a sculpture and installing it, Raimondi must represent an uncreated work to the municipalities and institutions that will commission him. For thirty years he has attracted one prestigious commission after another without the advocacy or comforting buffer of either agent or art gallery. From start to finish Raimondi negotiates several worlds, where art and commerce merge more or less as they did for those quattrocento masters who built and decorated the great churches and public buildings of Florence. The number and significance of the commissions awarded Raimondi and the beauty of the work he has completed are proof that his monumental art is thriving.

But vast America has no Florence. Although there are Raimondis in twenty-seven states and in Europe, some major pieces are scattered, three in unlikely Nebraska alone. Unlikely because the state, or so it would seem, is outside the mainstream of American art to everyone but the monumental sculptor who builds work where the commissions are. Between 1976 and 1990 three national competitions in Nebraska attracted hundreds of sculptors from across the country. John Raimondi won them all. Today *Erma's Desire, Dance of the Cranes,* and *Athleta,* important American sculptures by any standard, are off Interstate 80 outside Grand Island, at Omaha's

Eppley Airport, and at the University of Nebraska at Kearney's Health and Sports Center.

The nature of Raimondi's art, its growth and development, can be traced in these Nebraska pieces. And since a finished, standing work of monumental sculpture is always more than meets the eye, much else can be learned as well. A sculpture's scale and placement inevitably raise questions. How was it made? Why here? Why now? Who decided on this design? And what did they hope this work would say to those who happen upon it? All of these questions have answers.

Every work of art has a history *after* it enters the world. Monumental sculpture, from the Parthenon friezes, to Michelangelo's *David,* to Pajou's *Buffon,* Saint-Gaudens's *Abraham Lincoln Memorial,* and Raimondi's *Dance of the Cranes,* has a biography, a past as revealing as that of any human life. This story is rich in technical, social, and, at times, political detail. At every turn it reveals the artist's vision and the vision of those his art attempts to locate, clarify, and realize in physical form.

John Raimondi built his first monumental sculpture in 1970. Four years later Nebraska awarded him his first big commission. To celebrate America's bicentennial, the state, in concert with the National Endowment for the Arts, decided to place sculptures in the parks along Interstate 80, which runs from Omaha through Lincoln, Grand Island, Ogallala, and on into Colorado. The *New York Times* published a call for proposals to which Raimondi responded. Of the sixteen plans chosen in competition, eight pieces were completed and can be seen today. Raimondi's *Erma's Desire* is east of the Platte River,

Dance of the Cranes (detail), 1988
Bronze, 60' tall x 33' x 15'
Omaha Airport Authority

15

Erma's Desire, 1976
Cor-ten steel, 26' tall x 47' x 33'
I-80 Bicentennial Sculpture Project, Grand Island, Nebraska

on eastbound 80 a few miles from the turnoff to the Henry Fonda Memorial Highway that runs to Grand Island. A plaque at the rest stop informs those who look at *Erma's Desire* as well as the other sculptures: "No one agrees on what each sculpture means. So much the better. In the spirit of American liberty people are free to think, feel and talk about them as they like." This down-to-earth disclaimer may be there because of the tempest stirred up by Raimondi's work.

When a drawing of *Erma's Desire* was published in a local newspaper, the piece met with such responses as "Not in my front yard" and "I wouldn't touch that with a ten-foot pole." That this drawing was not Raimondi's but a crude approximation done by an opponent seemed not to matter. Some who objected read sexual innuendo into the title. What else could Erma possibly desire? Others objected because as an example of modern art *Erma's Desire* made no sense, sexual or otherwise, to them. (The ruckus might have been more intense had Raimondi been granted his proposal to build the sculpture over I-80.) Those who fought *Erma's Desire* seemed to want recognizable images, a Conestoga wagon or group of pioneers, art that commemorated the glorious trek westward. The battle was joined over a building permit for the work.

The twenty-seven-year-old Raimondi grew a beard so as to look older and, stylishly besuited, went before his critics at an open meeting. He explained that *Erma's Desire* referred to his mother, Erma, and her desire to have a son named John. He meant the piece as his gift to her. To defuse the objections to modern art, which *Erma's Desire* surely is, Raimondi pointed out that his audience did not live in the past. They farmed using the latest methods,

drove trucks and not horse-drawn wagons, and had telephones in their homes. Since their lives were modern lives, why should their art refer to a past in which none of them had lived? Why not an art of their moment?

It is impossible to say how many people his argument swayed, but it is important to note that Raimondi took his audience seriously. He did not dismiss their objections as philistine nor did he invoke art's transcendent values and give a sermon on how *Erma's Desire* could only better the inner lives of all Nebraskans. As self-expressive as *Erma's Desire* is, Raimondi also desired that it speak at least to, if not for, those in whose backyard the piece would stand.

The Cor-ten steel sculpture sends three steeple or lance points (Raimondi thinks of them as spires) toward what the native Nebraskan Willa Cather called in a poem, "the eternal unresponsive sky." One who stands in the midst of *Erma's Desire* must follow the thrust of the sculpture up into that sea of sky. The plains appear to go on forever, but that forever is as much sky as rolling land; the emptiness is magnified by the immensity overhead. What shelter is there from all this openness?

Within the lower angled teepee shapes the prairie wind is broken, and one imagines at least a respite from the elements. *Erma's Desire* is mindful of where it stands in two ways: the viewer honors the dome of sky above while contemplating what it takes to survive on this land. The sculpture soars but at rooflike angles. The lower elements cluster. Thus two Nebraska realities are celebrated.

The material, Cor-ten steel, and vocabulary of straight edges, angles, and slabs are those of modern sculpture from the 1970s. Ronald Bladen, Richard Serra, Clement

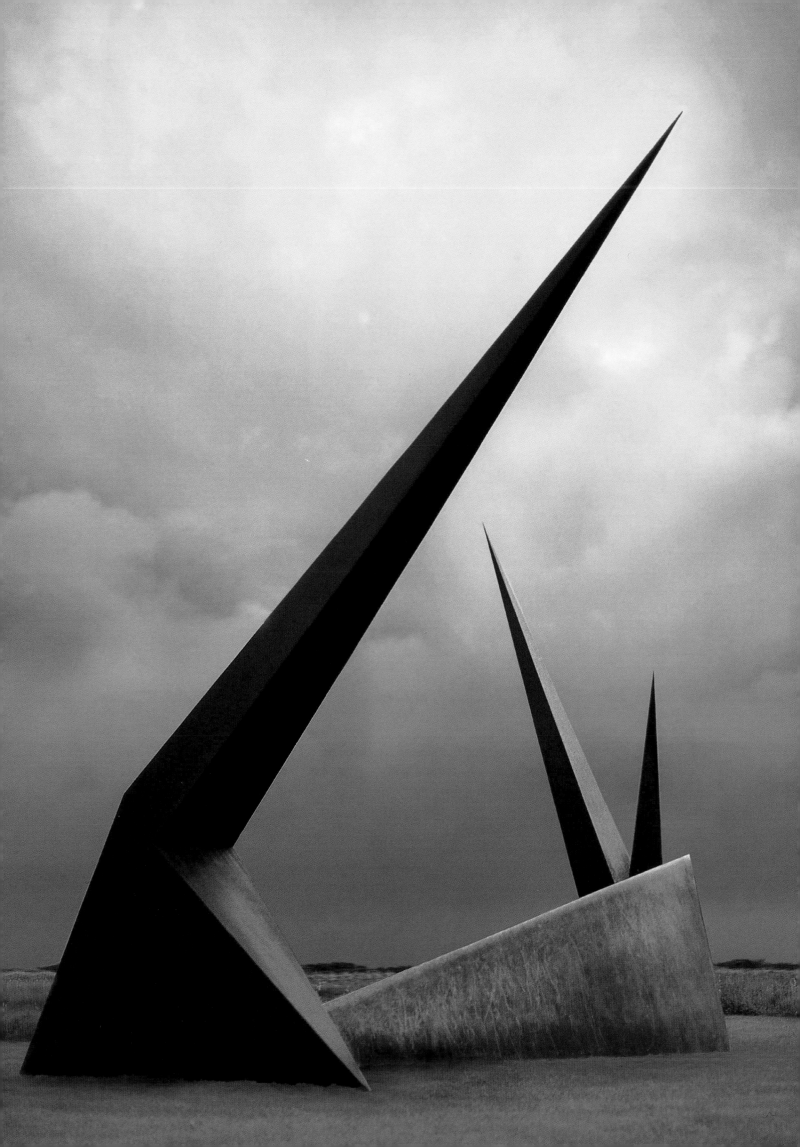

Meadmore, David von Schlegell, Donald Judd, and other sculptors put them to work during that time, as Alexander Calder had done before them. Raimondi spent the six years after art school in Maine and Boston mastering these forms. Severe, bold, and dramatic, *Erma's Desire* is just right for a landscape perfect for sculpture. The scale of Nebraska's plains and sky transforms the arching insectlike sprinklers that water the cornfields and the sheet-metal corncribs shaped like German beer tankards into works of sculpture. The Nebraska writer Wright Morris described the cement grain elevators that can be seen for miles as "Egyptian." *Erma's Desire* has a similarly powerful presence.

Raimondi returned to Nebraska twelve years later, in 1988, on a much bigger commission. The work he built to satisfy it is a quantum leap from *Erma's Desire*. In *Dance of the Cranes* Raimondi came into his own as a monumental sculptor. Representatives of Omaha's Eppley Airport desired a "signature" sculpture, something, perhaps, like the St. Louis Gateway Arch that could function as the logo of a revitalized city. The airport's sculpture board had its mind's eye on something to do with flight. Realistic? Abstract? The members were not sure. They thought they would know what they were looking for when they saw it.

And so they winnowed down some two hundred applicants to five, one of whom, the least well known nationally, was John Raimondi. The only one of the five to have flight on his mind, he proposed an image derived from airplanes. Though he had studied the history of aviation and visited the Smithsonian's National Museum of Air and Space, Raimondi thought he could profit from the airport board's input. While the other finalists stayed home—they had proposed works created in their studios—he visited with Russ Klay, the airport's executive director. It was Klay who suggested that Raimondi look beyond manned flight to the birds and specifically to the sandhill crane.

In March sandhill cranes migrate north from the Gulf of Mexico. On their way to summer quarters in Canada they stop for six weeks or so at Nebraska's Platte River. They arrive in the hundreds of thousands, and during their stay along the shallow Platte they dance in their mating ritual. Nebraskans and tourists camp by the river and enjoy the spectacle the birds provide. Those who have been there speak of arriving cranes darkening the daylight sky, a vision from an earlier America. The sandhill crane is a gray bird, roughly four feet tall, whose bare forehead is red. They have the long sticklike legs common to their species. In flight they stretch their bodies straight as arrows while their wings slowly, powerfully, rise and fall. Their call is described as "long and penetrating."

That spring Raimondi journeyed to the Platte. As soon as he saw the cranes he knew the image of flight must come from them. Now he had to find that image. He went about this by doing what he had previously done in creating *Aquila* (1981) and *Lupus* (1985). As Raimondi had studied eagles and wolves, he now studied the sandhill crane. This took him to Harvard's Museum of Comparative Zoology, where he examined, and drew, the bird's skeletal structure. As he studied, he drew the bird realistically. Once again he felt the need to ground himself in reality, to give his imagination facts to work from. He would agree with Wallace Stevens: "The real is only the base. But it is the base." His first crane drawings could illustrate a field guide.

Once he grasped the lineaments of the crane, Raimondi began to improvise, but only after he had taken numerous photographs of the birds at their Platte River nesting ground. Raimondi is a first-rate draftsman who moves easily between representation and abstraction. In his studio, he loaded two brushes with ink, concentrated on the crane motion he wanted to capture, and, sometimes in no more than thirty seconds, drew the shapes of wing, feather, thrust-forward neck, and the jig and strut of the birds dancing. Or he caught them in their landing and taking off. In these drawings he found the source of the image that became *Dance of the Cranes.* Some years after he had completed the piece, while searching for something else, he came across one of these drawings. It was turned on its side, and there, instantly, he recognized the image he had settled on. The image had been in him, he now saw, before he knew it.

Raimondi's next step was to build a roughly forty-inch cardboard maquette. His sense of scale, which he believes was honed through building countless model planes and cars in childhood, tells him that from here he can go on to fabricate a ten-foot garden-scale version and, in the case of *Dance of the Cranes,* to the sixty-foot monumental sculpture, without losing his image. The maquette itself is flimsy, held together by cellophane tape, but it is enough for the fabricator to go on. Here begins Raimondi's need for collaborators.

Having fabricated *Erma's Desire* himself and in the process mastering arc welding, Raimondi knows his way around a metal shop. This experience has given him a firm grasp of the crafts involved in building his work and a clear understanding of how much time and materials cost.

Both are crucial, but not all who undertake monumental sculpture master them. Those who do not may have their vision realized by master craftsmen, but they risk going broke. To build and deliver his sculpture on time and earn something for himself, Raimondi knows that he has to bill out his fabricators at a certain figure. His experience tells him what he can get for that figure and this, in turn, has to jibe with what he wishes to build. To be sloppy in any of these calculations can not only compromise the sculpture itself but also lead to the wrangles and bitterness that come with unforeseen costs.

Maquette in hand, *Dance of the Cranes* took a surprising, and to Raimondi, exceedingly welcome turn. His plan called for Cor-ten steel and a height of forty-five feet. But the Omaha Airport Authority had grown so enthusiastic about the work that it asked Raimondi how, if he were given carte blanche, he might enhance it. He told them *Dance of the Cranes* could be built at sixty feet and in bronze. The authority's unanimous vote to do this delighted Raimondi. Bronze brought *Dance of the Cranes* into the ancient tradition of sculpture, and because bronze is malleable it can be worked with to achieve a graceful flow impossible in Cor-ten. And bronze opened up more possibilities for color. *And* on completion, at sixty feet tall, *Dance of the Cranes* would be one of the tallest bronze sculptures in North America.

Once the required bronze sheets were rolled and prepared at the Revere Copper Company in New Bedford, Massachusetts, Raimondi went to work on them at Lippincott's in North Haven, Connecticut, at the time this country's premier fabricator of large-scale sculpture. He had worked there before and been made to feel at

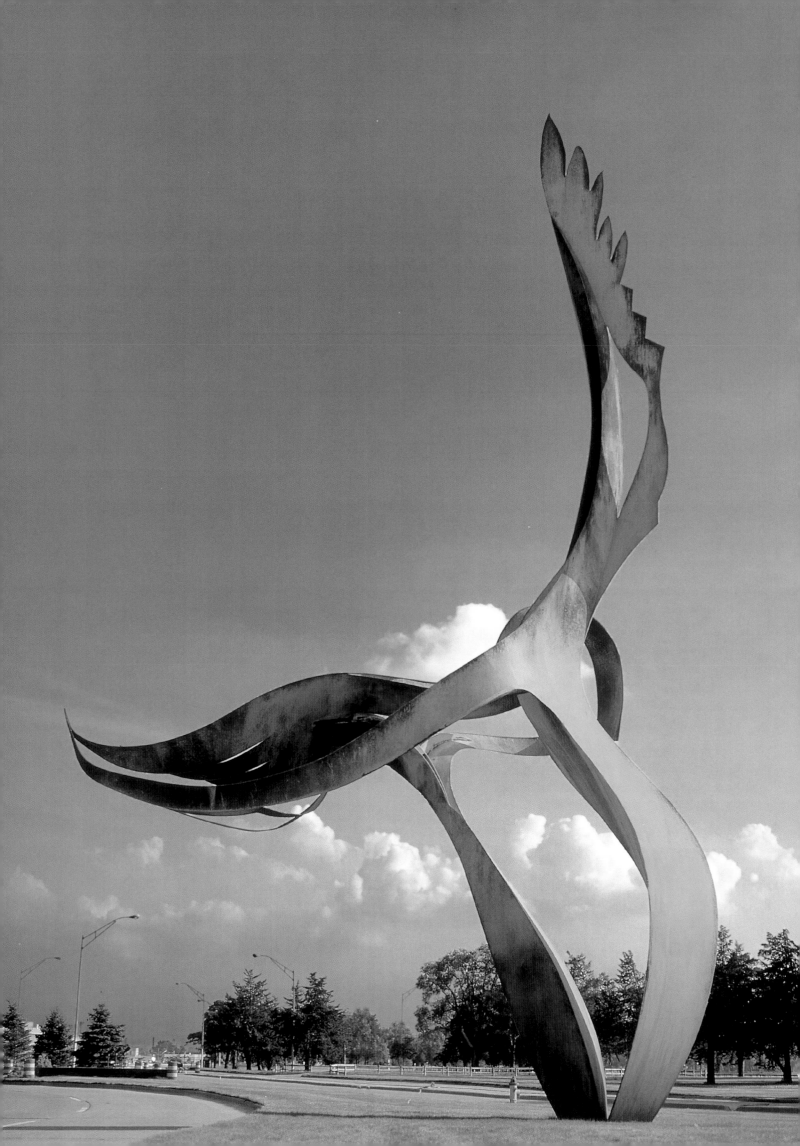

home by the brothers Alfred and Donald Lippincott. (He now works mostly out of Milgo-Bufkin in Greenpoint, Brooklyn.) At home in Palm Beach he and his partner, architect Ralph Cantin, whose advice and encouragement are vital to Raimondi, share a studio. It is really little more than a small office: bookcases, desk built into one wall, a large table topping storage drawers in the room's center, and a bare wall that shows signs of having been used for drawing and painting. This is all the room Raimondi needs for the first two steps in his process.

At Lippincott's Raimondi had a top-flight crew led by Kym Grant who went about the work with vigor and single-minded purpose. (Their intensity can be seen in the video *Dance of the Cranes* produced by Nebraska's public television station.) Working from the maquette, they built a ten-foot model. After determining the character of the image and the material from which it will be built, this is the next crucial step. In this transition the sculpture assumes its all but final form, and in the process, the larger size calls for subtle, and on some pieces broader, changes. Raimondi and crew now work where engineering and art overlap, where what is desired meets what is possible.

The model having been built, the full-scale *Dance of the Cranes* can now follow. With this piece, as with the majority of his public commissions, Raimondi has a deadline hanging over him. Here again his command of materials and machines is key. If he goes over deadline he not only disappoints his patron, in this instance the Omaha Airport Authority that had announced a public celebratory unveiling, but also pays a penalty in cash for each day the sculpture is not installed.

The actual building at the fabricators calls for a combination of brute strength and great delicacy from men and machines. The bronze must be formed to realize Raimondi's lines, but where bronze meets bronze, that marriage and the welder's bead that consummates it must be clear and flowing as a drawn line.

As this work progresses problems are inevitable. In *Dance of the Cranes* a significant one arose as Grant and his crew attempted to join the piece's two forms at the base. Raimondi envisioned the two as poised to suggest cranes both landing and about to take flight. To achieve this Grant thought a hydraulic jack could bring the two elements together. He set this in place, and the jack forced the elements tantalizingly close together before they slipped apart. He gave it another try, but again they separated with a loud, discouraging *boing*. There was nothing to do but load the elements for shipment and hope gravity would accomplish what the jack could not. In other words, as *Dance of the Cranes* was hoisted into place at its Nebraska site, the elements, which had never before been joined, were expected to come together in accordance with natural law.

This is exactly what happened, but not for another six weeks, weeks in which Raimondi and crew were put to the test by unseasonably cold weather and other unforeseen difficulties that can arise to bedevil an installation. *Dance of the Cranes* arrived in Omaha on two flatbed trailers and was unloaded to the ground without incident. In the video Raimondi arrives at the same time, pulling up in a convertible, dressed in a hooded Harvard sweatshirt ready for work. Ralph Cantin was already on the site. At the outset things went smoothly, and the solution to one

problem demanded nothing more than digging a hole so the sculpture could rest easily on its side. But everyone knew that the fifteen tons of sculpture would be assembled for the first time only when actually erected. They also knew that one does not merely plunk down fifteen tons, especially fifteen tons that must sit on a small concrete base to achieve the exact effect the sculptor wants.

While they planned the installation, a patina had to be applied to the sculpture. Here the weather interfered. Several windy thirty-degree days, in April no less, made the necessary sandblasting problematic and the bronze itself too cold for the patina, once applied, to set properly. The weather did not relent, and there was nothing to do but go forward in difficult conditions. Endeavors of this kind tempt the gods who, it seems, are more likely than not to humble artists who act on such a grand scale.

A single construction crane was positioned to lift the elements simultaneously and lower them to where they could be aligned and bolted into place. The video documents this operation, and we see consternation on the face of Raimondi and everyone involved when a cable snaps, the bronze sways, flapping, and comes within an ace of crashing to the ground. But the other cables held, and after a hurried consultation a second crane was brought in. Acting in sync, the cranes lowered the elements so they could be tugged exactly into place. Gravity caused them to meet, replicating for Raimondi his vision of a year before on the Platte.

The video shows the joy, cheers, and celebratory whoops of those present when the sculpture first stood in place and the tears of joy at the dedication. We already know that *Dance of the Cranes* expressed what Raimondi

felt, and now we see that he also realized the dreams of those who awarded him the commission. This hoped-for marriage of private and public, of artist's vision and committee intention, is a marvel denied those artists who work, as most do, in solitude. Beyond recording a story that is photogenic from the moment the first bronze sheets roll from giant machines to the scattered chairs at the close of the dedication, the video celebrates this rare harmony. What it cannot adequately show is *Dance of the Cranes* in situ.

No one expects contemporary monumental sculpture to exist in the white box that, thanks to New York's Museum of Modern Art, we regard as the true home of modern art. The commissioning agency, in most cases, selects the site, and the sculptor deals with it as best he can. *Dance of the Cranes* stands in a very American space bordered on one side by a four-story parking garage, the generic parking garage that exists across the country, and on the other by the Missouri River. Roads that lead into and out of the airport curve around *Dance of the Cranes*. This makes for little pedestrian traffic. In the moments it takes to pass *Dance of the Cranes*, viewers look at it through their car windows. For the sculptor this is far from ideal.

Since the viewer has so little time to take it in, Raimondi made *Dance of the Cranes* bold and quick. Its height allows it to survive the matter-of-fact ugliness of the parking garage and gives the graceful outstretched wing shape immediate impact. As the curves of bronze shear through air, the forms appear to have been drawn against the sky, fast as flight itself. Seen from another angle, with the river and the trees that border it as background, the beautifully poised bird forms simultaneously alight on and rise from water.

From a distance the eye is drawn up to the notched feather rising from the play of curves below. This suggests the sandhill crane, but Omaha takes its name from a Sioux- speaking Indian tribe native to the region. Red Cloud and Crazy Horse rode the plains that travelers are about to enter, and these Indian chiefs may come to mind. Raimondi accomplished a fusion of Nebraska's natural world with the human history of the place. Sandhill crane and Sioux war bonnet are entwined with a welcoming flourish that waves the visitor on to the west that begins here.

The great formal leap *Dance of the Cranes* takes from *Erma's Desire* is the curve. As we will see, this did not happen with the slash of Raimondi's ink-loaded brush. Drawing had become the driving force in *Aquila* and earlier in *Zephyrus* (1980), a pivotal work in Raimondi's evolution. Whereas *Erma's Desire* looks structured, like a dwelling, *Dance of the Cranes* is plucked from the air. Raimondi's breakthrough took place on two levels. He looked outside his experience to the natural world for a visual equivalent to his intuition that the sculpture must embody flight. And nature, about which Raimondi is "romantic" in the Wordsworthian sense, demanded of him a lyricism, the split-second reach and grasp of drawing. *Dance of the Cranes* invites the viewer to contemplate its curvaceous flow, and the eye apprehends sensuousness as the bronze delights in it. The work is epic in scale, lyric in intimacy and intensity.

Raimondi returned to Nebraska for a third time after being awarded a commission that he had applied for in an unorthodox manner, a commission he was bluntly warned that he had little chance of getting. It was pointed out to him, that since he had won two Nebraska commissions, a third was, at the least, highly unlikely. The University of Nebraska at Kearney, not far from Grand Island, had built a Health and Sports Center. The college envisioned a sculpture for the relatively small and unprepossessing space at the building's entrance. The work would have to symbolize and celebrate the nature of the various sports taking place in and around the center.

When Raimondi was named a finalist in 1989 and paid to produce a model of his design, he instead presented a concept written on a single sheet of paper. He proposed that he come to campus as an artist-in-residence and while there "find" his image in observing athletes at practice. In the video *Grammar of Bronze,* shot by the college's Film Department, Raimondi defined the process thus: it is "not a science, it is an exploration." Kearney's president knew instinctively that Raimondi's approach was the right one and accepted the concept.

Again, drawing would produce his image, but before he put pen to paper he took a series of photographs. As Raimondi observed sports that were played in the building—swimming, wrestling, volleyball, basketball—or were centered there—football, track and field, baseball—he thought he could isolate a single motion, the instant in which the volleyball spiker or baseball pitcher concentrated the athleticism of the respective sports. To see this instant clearly, Raimondi made Eadweard Muybridge–like stop-action photographs of a pitcher going through his motion, a punter punting, and a discus thrower uncoiling into her release. In these images Raimondi isolated the pitcher's arm in full extension upward at the point just before he releases the ball toward the plate, the volleyball player's

Athleta, 1990
Bronze, 29' tall x 20' x 12'
University of Nebraska, Kearney

arms reaching up to block a shot, the punter's leg raised aloft just after he has boomed the ball downfield off his toe, the curved buttocks and taut thighs as the athlete strains to get the most out of herself.

The collaborative nature of Raimondi's collecting his images from the school's athletes is obvious, but the collaboration also occurred on another, subtler, level. The completed sculpture embodies actual Kearney athletes, young men and women not very different from those who will go through the building's doors for decades into the future. Thus the androgynous mythical figure that Raimondi came to call *Athleta* arose from the community whose emblem she is. Just as viewers imagine the Sioux headdress in *Dance of the Cranes,* so too they glimpse the volleyball player from Hastings or Minden in *Athleta.*

During the time it took to build *Erma's Desire,* Raimondi lived in a Holiday Inn in Grand Island and, when not at work on the sculpture, spoke to Kiwanis and Rotary Clubs and in churches and schools. Of the eight bicentennial sculptors, he was the only one to build his piece on site and to function as a Johnny Sculptureseed, traveling artist-in-residence. Some sculptors leave the installation phase to workmen who have been given detailed instructions. Not Raimondi. Being there to apply the right patina in the right way or to guide the work into place and to solve any problems that come up is part of his artistic credo. With *Dance of the Cranes* he remained on site from arrival to unveiling, eager, as his gregarious nature dictates, to have personal relationships with those he works with. In Kearney, Raimondi opened his campus studio to all those who wanted to take part in building *Athleta.* For six weeks students came to watch, and although he did not mind onlookers, he wanted workers and he got them. In effect, he gave a master class in monumental sculpture to students who would, Raimondi hoped, one day feel that *Athleta* was theirs. *Grammar of Bronze,* which allowed even more of the university community to be involved, tracks those weeks. The work it records is like a military campaign in that an objective must be reached by a certain date, and, of course, there is the possibility that a process dependent on crane and hoist, muscle and fingertip control, will have at least one nerve-wracking, if not disastrous, moment.

Grammar of Bronze shows Raimondi to be a natural teacher. He is neither didactic nor does he come across as authoritarian. He is clearly adept at the physical tasks sculpture requires and knows how to tell interested students what they need to do to help him. He is their comrade. What he communicates about art is not aesthetic theory, but the practice of paying attention to detail and following through, the nature of the work itself and the recompense it provides. The viewer feels his pleasure in the give and take of such collaboration.

Athleta went forward to completion without any of the problems that beset *Dance of the Cranes.* On its squat, circular concrete pedestal, around which runs a bench, *Athleta* looks like a whirling ballerina atop an old-fashioned music box. She conveys, from all directions, the kineticism of sport. She is poised on tiptoe, her nicely rounded buttocks thrust out, arms raised high in triumph, one extended leg, bent gracefully at the knee, suggesting any one of a dozen sports. *Athleta* is a hymn, not to victory, although that can be seen in her upraised arms, but to participation and the grace achievable in sport.

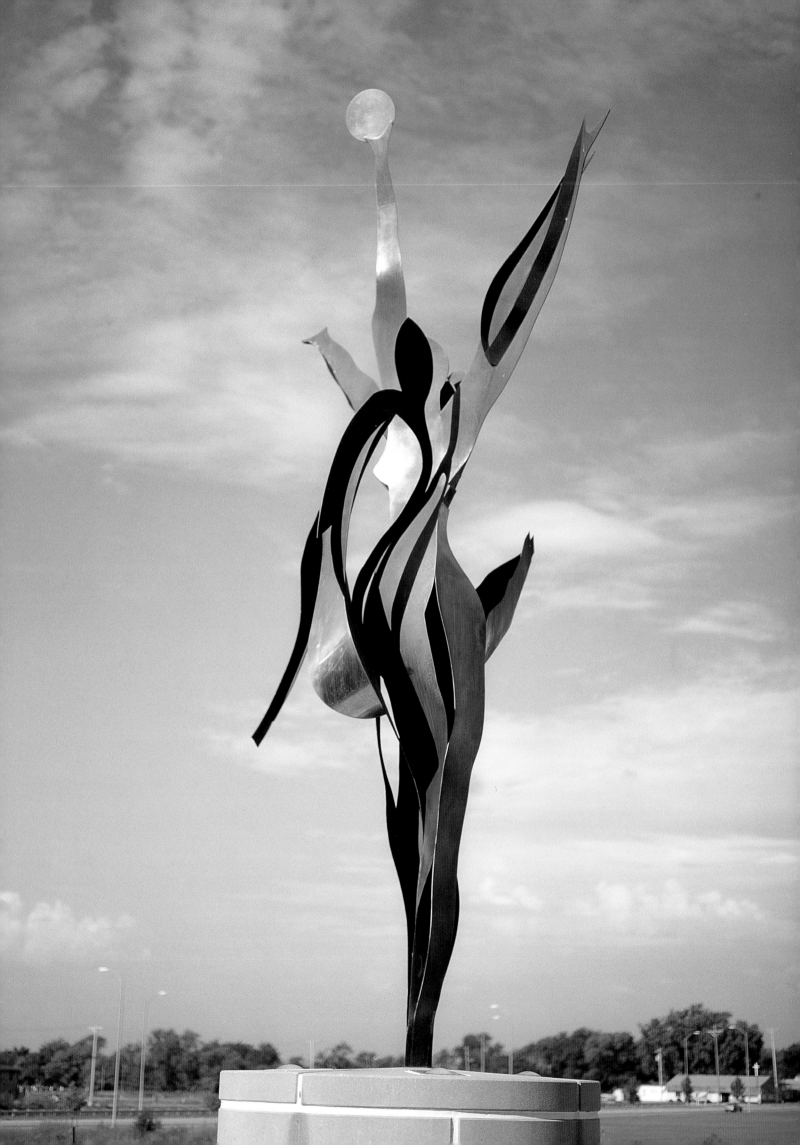

No one would honor a goddess figure that appeared shy about her attributes, and *Athleta* is not shy—she broadcasts them. This is a goddess risen from the open country in which she stands, frankly proclaiming the pleasures of physical release in sport. As students leave the doors of the Health and Sports Center they see her at her best, outlined against the big sky of their country.

Omaha . . . Grand Island . . . Kearney linked by I-80. And Lincoln, home of the University of Nebraska, on whose campus stands the Sheldon Memorial Art Gallery. For a college museum, the Sheldon has an unusually large and comprehensive collection of contemporary sculpture, which allows one to measure Raimondi's achievement as an artist. At the museum itself, and placed around the campus, are works by David Smith, Reuben Nakian, Mark di Suvero, Michael Heizer, and Richard Serra. Recently, Claes Oldenburg and Coosje van Bruggen's hilarious *Torn Notebook,* a notebook on its edge, thrown down by a frustrated student, its pages flapping in the breeze, joined this formidable company. How does Raimondi stack up? Very well, indeed.

All American sculptors working in metal after David Smith are in his shadow. Raimondi descends from Smith's lyrical side, visible, for instance, in the table sculptures, those painted steel drawings in space. When Smith built vertically he favored the totemic form, bulk on bulk balanced in air. Raimondi tends to send up flame shapes or ribbons taken by the wind. He has nothing of Smith's weight or mass, his resistance to space. Nor is Raimondi drawn to the sort of industrial materials di Suvero manipulates. He seeks a classic sleekness, feminine in its curvaceous forms. I-beams, heavy timbers, boulders and

hawsers of rope are not for him. Where a di Suvero sculpture is rough-and-ready, and one imagines the heavy-booted, thick-gloved labor that went into it, a Raimondi is refined and Apollonian, with all evidence of physical work left in the studio.

Of all the sculpture at the University of Nebraska, the most instructive to compare with Raimondi's is that of Richard Serra. The differences between the two men's work are illuminating. Serra's piece is a cone of Cor-ten steel that you enter, and once inside, enwrapped, you naturally look up and sight along the narrowing barrel as if you were looking through the wrong end of a telescope. The sky is as small and far away as the one a prisoner sees from his cell. The work has Serra's breathtaking audacity. He tells you where to stand with an authority that is wholly disinterested. Space is now his, and you can take it or leave it. Serra is a very powerful annihilating artist, capable of striking fear in any viewer's heart, a rare emotion when looking at art. But when one looks at a Serra, the sculpture looks back. The gaze is blank and obdurate in its indifference. It is difficult, if not impossible, to mistake a Serra for the work of another sculptor. Raimondi has never been interested in developing this sort of signature style. When a Serra is created for a monumental context, as was the ill-fated *Tilted Arc,* it is first of all a Serra. Raimondi's *Dance of the Cranes* and *Athleta* give shape and coherence to the desires of those who commissioned them. If *Dance of the Cranes* stood before the Kearney Health and Sports Center it would say "art," not "athleticism." Nor could *Athleta* be the household goddess of the Omaha Airport. Raimondi's monumental work is site-specific in that he places his muse in the service of others.

Serra is the epitome of the single-minded artist who means, as he said nearly thirty years ago, "to follow the direction of the work I opened up early on for myself and try to make the most abstract moves within that. . . . To work out of my own work." It is impossible to imagine him searching for an image by photographing Kearney State students as they played sports. As impossible as imagining a Raimondi sculpture arousing the hatred that led the federal government, which had commissioned Serra's site-specific *Tilted Arc*, to destroy the work. Raimondi has a vocabulary of forms descending from Rodin and Brancusi that he enlarges and adapts to the commission at hand. Serra is a studio sculptor who speaks his own language in public. Raimondi hears what others say. When he speaks he has absorbed their accents into his own voice.

* * *

When we speak of the creative artist we must speak of affection—intense affection which the artist has for his work. An affection, along with belligerent vitality and conviction. Can the critic, the audience, the art philosophers ever possess the intensity of affection which the artist possessed? Do they extend affection and vitality into the effort of understanding? Can they project his intense affection to the work of art? Or do they miss it?

—David Smith

John Raimondi believes that by age seven a human's character is essentially formed. His belief is reinforced by the memory of a junkyard across from his family's first apartment in working-class East Boston, Massachusetts. He first saw arc welding there, lighting up the snarled heaps and stacks of scrap metal. He remembers seeing a dead cat in the junkyard among the I-beams, lolly columns, and steel rods. This gave the place a scary and seductive mystery, powerful enough that he often returned to it after his family moved a few blocks away.

Raimondi's family rented the first floor of their East Boston house to Arnold's Hobby Shop. There, before he began grade school, Raimondi discovered model airplanes, military vehicles, and HO train sets. Guided by his father, he built his first models. Soon the activity obsessed him.

Arnold's held another wonder for Raimondi: coins. He enjoyed hunting through change for a find, learning the history of coins and, as much if not more, buying and selling them. Today, when Raimondi thinks of Saint-Gaudens, it is not the sculptor, whose Cornish, New Hampshire, home and studio he has visited several times, but the sculptor's twenty-dollar gold piece. On its face the image of Liberty is raised in bas-relief. Raimondi values it as the most beautiful of American coins. Raimondi's father, Peter, also got involved, at least in the hunting and gathering end. Father and son had the ability to work together at things and enjoy themselves doing so. It may be that if you can collaborate successfully within your family you have learned how to collaborate with almost anyone and, if you become an artist, you are drawn to activities in which you can collaborate.

Model planes powered for flight by small gas engines came next for Raimondi, but his interest in coins continued, deepening when he realized that there was money to be made out of his hobby. His parents remember their

son as adept beyond his years at dealing with adults as he haggled and bargained to build his collection.

· This was not the John Raimondi the nuns who taught him in school knew. There he stuttered badly enough that reading aloud or answering questions in class was torture. Although he had been quick to read, he now had difficulty comprehending what he read. Today dyslexia would almost certainly be identified as the learning disability that slowed him, but forty years ago schools were ignorant of such things.

Raimondi's interests outside school became more than hobbies. He saw that he could give himself to these unstintingly and never be humiliated as he had been in the classroom. Years later Raimondi concluded that through high school he "compensated or over-compensated" for what he could not achieve in school. But these terms are inadequate to describe the drive Raimondi began to manifest even before he reached his teens. We commonly regard stuttering and dyslexia as minor handicaps that must be conquered if a child is to progress in school and socially. Raimondi no longer stutters, and although he reads slowly, he does so with powerful concentration. That he overcame these impediments is important, but of equal importance is that these lacks fueled Raimondi's drive to become a self-confident, self-sufficient person.

When he entered his teens, Raimondi's interest in building models waned. The family now lived in suburban Winthrop by the ocean, and Raimondi found the sea beautiful. He began to paint it in acrylic, mostly blues and greens. Color excited him more than form. While these paintings are a step toward the sculptor he became, no one thought of them as anything other than an imaginative boy's artistic outlet. No Raimondi had ever been

involved or interested in the arts. The family did not visit galleries or museums. For two generations, the Raimondis, both men and women, had left school as soon as they were old enough to work. They had no time for art. Young John picked up a paintbrush with a future in mind, and his proud parents framed and hung his paintings on their walls.

One afternoon Erma Raimondi looked out her picture window to see a flatbed truck turn the corner into her street. On it was what was left of a car, a wreck, with trees and grass growing through its missing windows. She remembers being thankful that this hunk of junk was not coming to her house. But it was. Her son had bought the 1939 Ford from an owner who had abandoned it in a field—hence the saplings and grasses. Raimondi went to work restoring and customizing it, soon developing another obsession. He now says that as he worked he "loved that car more than I'd probably loved a human being."

Into that car Raimondi put not only all his energy but the profits from the sale of his coin collection and, in hindsight, the emotional energy that might have gone into a high school romance. At the time Raimondi did not know that he was gay, but he knew his sexual instincts to be uncertain and bewildering. Not that he was ill at ease socially. Quite the contrary: his art had paved the way for him. He designed and built the decorations for school dances and created the cover for his class yearbook. His classmates respected his artistic bent, and friends were drawn to the garage by his work on the Ford.

Raimondi could not tear himself away from the car. After school, after dinner, all weekend—his parents had to drag him into the house or he would have been at it night and day. With the help of his father, who worked

in security systems, on the wiring, Raimondi completely rebuilt the car. His passion became so intense, his parents worried that he intended to be a mechanic, a grease monkey. His father approached Raimondi about this and was relieved to hear his son say he only wanted to get the car street legal and to be its "creator and driver," not to spend his life in a bay at the local Mobil station.

Raimondi got his hot rod on the road, albeit illegally at first. Having neither registration nor inspection sticker, he meticulously painted facsimiles of both and, at night, drove the car around town, much to his parents' dismay. But he had not worked so hard just to joyride. He wanted to compete for a prize in one of Boston's car shows. This led him to enter the Ford in the Street Rod Conservative class at the annual Autorama held in Boston's Prudential Center. The car won its division, and Raimondi was in heaven.

During this time Raimondi did not entirely abandon his painting. He had a studio in the third-floor, pitched-roof attic of his house, and there he could dream of becoming a great seascape painter. He was not shy about putting his work out into the world. Raimondi entered and won scholastic competitions and was in group shows at art associations. Because of this, his paintings appeared in the local paper and neighbors asked if they could see what the young artist was up to. Raimondi filled his portfolio and went to their homes where he displayed his work and spoke enthusiastically about it. To his delight, the neighbors bought paintings. He used the money to keep himself in art supplies and began saving for art school following his high school graduation.

The scene seems set for a replay of the American story in which the young artist must heed the call of his muse and break from an indifferent family or see his dream denied. Nothing like this happened in the Raimondi home. The family listened to the son's high school art advisor, who assured them that he had the talent to earn his living as a commercial artist. Raimondi had no clear idea what this might entail, but he had no other aspirations. He was advised to attend Boston's Vesper George Art School. When the school accepted him, he was determined to go, but there was not enough money, not even five hundred dollars for tuition. Raimondi felt that he could not ask his father to take out a loan, and so he sold his prized hot rod to pay his way.

At this point John Raimondi knew little about art beyond what he had learned by doing. He did not realize that his years of model building had given him a sense of scale. Nor did he know that in working on his Ford he had acquired a practical education in form, color, and surface. His parents and the culture Raimondi was raised in were not philistine so much as ignorant. Art, other than what their son made, did not exist in their lives. This is commonplace in America, but the lack of exposure, of a tradition, is not the crippling deficit Americans often believe it to be. American artists as different as Gertrude Stein, Charles Ives, Arthur Dove, Duke Ellington, William Carlos Williams, and Langston Hughes invented themselves. So did David Smith, who learned so much while working in Brooklyn's Terminal Iron Works that he gave that name to his Bolton Landing, New York, studio. In 1966, about to enter Vesper George, John Raimondi had probably heard no more than one or two of these names. They constituted no tradition that could inspire him. But he had acquired, without knowing it, the wherewithal to get himself started.

Vesper George led to work as a commercial artist, which proved to be a dead end. In the catalogue *Romantic Abstraction: John Raimondi, a Twenty-Year Survey,* published in 1992, the chronology for 1966–68 reads in its entirety:

1966 Attended Vesper George Art School
1967 Worked as a commercial artist for University Press, Winchester, Mass.
1968 Summer: toured United States; walked through Grand Canyon, inspired by enormity of scale.

When Raimondi walked the Grand Canyon, he had not yet been to New York's Museum of Modern Art nor had he seen any modern sculpture. Unwittingly, he may have followed the perfect progression for the monumental sculptor: nature, the truly monumental, first, and then art.

In January 1969 Raimondi decided to try school again and enrolled in the Maine College of Art, formerly the Portland School of Fine and Applied Arts in Portland, Maine. There he studied with the sculptor Norman Therrien, who opened doors for Raimondi that the fledgling artist eagerly went through. Therrien saw a grasp of volume in Raimondi's drawings and urged him to look at sculpture more seriously. He lent his student books on Brancusi, Moore, Calder, and Smith—all news to Raimondi and all eye-openers and inspirational. Therrien suggested Raimondi work in stone, and then did something he had never done before—he lent his own hammers and chisels to a student who had never used either tool to make sculpture. Therrien also gave Raimondi his first instruction in welding.

For all this attention and encouragement, Raimondi soon wanted more than Portland could offer, and he moved on to the Massachusetts College of Art in Boston, where he studied with another sculptor, George Greenamyer. He became Greenamyer's studio assistant and under him refined his welding and fabricating techniques. Almost at once Raimondi began to design monumental works. He also visited the Museum of Modern Art for the first time on a school-sponsored trip. He remembers his first sight of Brancusi's work and walking into the sculpture garden and seeing work by Smith, Moore, and Calder—artists whose work he had known for barely a year. He turned away from the garden's figurative sculpture—it was the abstract work that overwhelmed and excited him.

Raimondi suddenly knew what kind of artist he wanted to be, and he wasted no time in getting started. In April 1971 he designed and then fabricated in the school parking lot *Cage,* the first of what he came to call the *Cages and Castles* series. Cages refer to various arrangements of slats used to enclose spaces, and castles to the vertical thrust achieved by turret or steeple shapes. This series occupied him over the next eight years. Raimondi immediately entered *Cage* in a competition judged by, among others, the sculptor Clement Meadmore. *Cage* won. The prize? Exhibition on Boston's City Hall Plaza from April to June. Raimondi, helped by fellow students and teachers, installed the piece in pouring rain.

The twelve-by-seventeen-foot *Cage* is Cor-ten steel painted black. Two elements join to form a triangular void with a slanted top. The smaller element is bent at an angle the way a knee is bent when, sitting down, we

stick our leg out three-quarters. This props up the cage of slats, which is topped by a square-sided dunce's cap. *Cage*'s most arresting aspect, at least in the existing photograph of the work, is the shadow cast on the ground by the cage and its cap or peaked castle turret. This shadow has Expressionist force; Dr. Caligari might be lurking nearby.

Raimondi borrowed the money to construct *Cage.* His next piece won the support of Maine's Haystack-Hinckley School, which made him artist-in-residence that summer. There he built the sixteen-by-twenty-four-foot *Christopher* and, in the process, further refined his welding skill. The following year he built a garden-scale (roughly eight to fourteen feet high) *David* and the monumental *Nod. David* went unsold, but Bridgewater State College, in Bridgewater, Massachusetts, acquired the twenty-foot *Nod.* Raimondi had come a long way in a very short time. In less than two years he had built four pieces and had his first big sale, and he was not yet twenty-four years old.

In 1973 Raimondi became the first member of his family to graduate from college, and that summer he received his first commission. Massachusetts Art Summer, a state program, chose him to build his first site-specific sculpture alongside a highway in Bernardston. Raimondi moved there, and went to work on *Stephen's Summer.* Although grouped in *Cages and Castles,* it differs from the others in that series in two ways. Firstly, it is horizontal. Awarded an expanse of flat ground beside the highway, Raimondi turned it into a roadside attraction. You can read *Stephen's Summer* as if it were a sentence formed by a triangle, circle, and column as parts of speech. Secondly, some

of these forms are rounded. With one notable exception the curve is otherwise absent from Raimondi's work until *Zephyrus* (1980).

Raimondi went from *Stephen's Summer* to an NEA-sponsored artist-in-the-schools program that placed him in Quincy, Massachusetts. There he moved both forward and, as the nature of his art requires him to do even today, backward. Working with the Quincy students he built his first private commission, *JAT,* named for Jim and Tracey Spates, who commissioned the work. *JAT* (thirty feet tall) is Raimondi's version of the obelisk. It is forthrightly phallic as it rises from its rounded base to its sharply pointed pinnacle. From where the curve of the base meets the shaft to the pinnacle, *JAT* is slatted or runged, front and back, forming a cage that could hold a standing man. Because over the previous years Raimondi had increasingly identified himself as a gay man, not to read a meditation on, or perhaps declaration of, sexual identity into this work would be to miss its point.

And yet, just what *JAT* broadcasts in its solitariness is ambiguous. Is one imprisoned within this phallus, caged inside one's physical being because that is the nature of things? Or do cultural forces impose this prison on us? If we are men, our duty is laid out for us as clearly and unequivocally as *JAT* holds its space. If, that is, we are heterosexual men. But if we are gay men, we honor our bodies in other ways, or seek to, so that the identity we might brandish becomes a cage of "deviant" desire. At first view *JAT* seems obvious, but a second look reveals it to be obvious on purpose. Raimondi wants us to look twice at what we think we know, and only then will the cage's complexity begin to come through. But what of the

Cage, 1971
Cor-ten steel, 12' tall x 17'4" x 3'
Exhibited at Boston City Hall Plaza

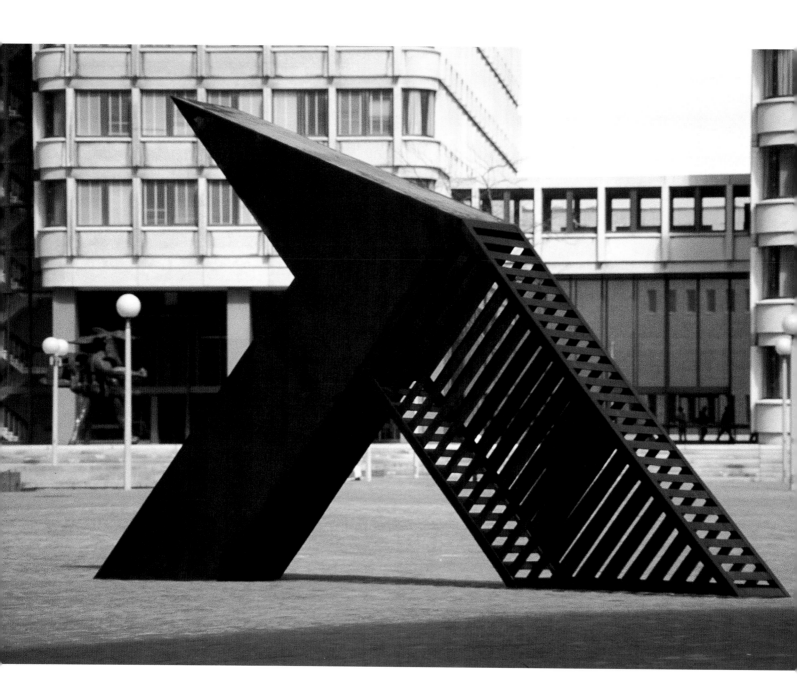

uninitiated who do not have the benefit of Raimondi's biography? *JAT* stands in a field in Geneva, New York, where, surrounded by trees and grasses, it loses the martial force natural to obelisks. On this site its angles and curve suggest a standing figure, certainly a man, but a man caged within himself, locked up. In its bristling isolation, *JAT* fuses both cage and castle.

While fabricating *JAT,* Raimondi looked backward twice. First, he bought a 1969 Corvette and worked with his students to rebuild and customize the car. He also returned to *David.* Now that he had the financial wherewithal, he wanted to make a full-scale, twenty-foot-high version of the piece.

The monumental sculptor's career, like the architect's, is filled with aborted, half-realized, and never-to-be-realized plans. Some pieces never get beyond the model stage. When the commissions they were built for go to other sculptors, these models are moribund. (As we shall see, the occasional model can be called back from limbo to be given a second chance.) Then there are pieces that, for one reason or another, usually lack of money, do not reach their full size. These may be appropriate as garden sculptures, whose scale allows them to be sold, but not all can be adapted to this purpose. Last are the pieces that reach their full size but not in the preferred material. Again, either the project or the sculptor lacked the money to complete the vision. Invariably, there are a few pieces that, like the *Erma's Desire* overpass, remain dreams.

The monumental sculptor wants as few pieces in all these categories as possible. Unlike paintings, sculpture, or drawings stored in a studio, unfinished projects do not represent inventory. Nor can they, if the work in ques-

tion is site-specific, be easily recycled for the next competition. Because of the time and money it takes to see any projected monumental sculpture finally installed, the artist is denied the freedom of abandoning work and must ration the pleasure to be had from pursuing an idea just to see what might come of it. He will have only so many chances, and once started he must finish. And it is incumbent on him, at least according to the critic, museum curator, and Raimondi champion Harry Rand, "to hit a home run" every time at bat.

Over the next six years, as Raimondi worked on the *Cages and Castles* series, his world began to expand. At the Brockton (Massachusetts) Art Center he had his first museum show in 1974, and when Maine's Portland Canal National Bank bought *Michael* he had his first sale to a corporation. How this came about illustrates the one-thing-leads-to-another route by which monumental sculpture often finds its way to a public place. In 1974 Raimondi returned to Boston's City Hall Plaza as an artist-in-residence for a summer Works in Progress project sponsored by the Institute of Contemporary Art. On site, assisted by John Sullivan and James "Chip" Morel, Raimondi built the spider-legged *Michael.* He only had money enough to fabricate the work in Cor-ten $^1/_{16}$ inch thick. Thus it could be lifted into place, but its thinness meant it could not be permanent. Because of the strong, spontaneous responses Raimondi got as he worked on site from people on their way to and from their jobs, *Michael's* short life did not disturb him. Though the piece had to be destroyed, he was heartened by the power of his art to move the man and woman in the street. He now had firsthand evidence of the impact of public art.

Then Raimondi went to Portland on another NEA artist-in-residence appointment. The teenager who showed, and sold, his paintings to his Winthrop neighbors had grown into a confident young man, unafraid of approaching corporations that might be interested in his work. If a site appeals to Raimondi, he will call or write the owner suggesting that he create a work for the site. He knows that his work is beautiful, believes that others will see it as he does, and since they might not find the work on their own, he will bring it to their attention. Raimondi now has an administrative assistant whose job includes researching and applying to suitable competitions. This is like entering the lottery, but without commissions the monumental sculptor has dreams but no art.

Eventually, the Canal National Bank, owners of a site Raimondi considered perfect, commissioned *Michael* (this time in ⅜-inch Cor-ten) and then presented the work to the city of Portland. While Raimondi built the piece, he wore a T-shirt he favored during these years. It read:

<div align="center">

JOHN

RAIMONDI

SCULPTOR

</div>

Pride showed in this. He had become a man with a profession. But this is not the sort of display artists usually make. The unspoken rule is that it is crass for the artist to call attention to himself.

<div align="center">

JASPER

JOHNS

PAINTER

</div>

Unthinkable!

Raimondi has never been one to be intimidated by how artists ought to conduct themselves. In this he is a maverick, unashamed and relentless about promoting his work, both privately and publicly. But then, although he has had a number of gallery shows, he has never had long-term gallery representation, nor has he had a solo show in New York. What Leo Castelli, Mary Boone, and Larry Gagosian do for their artists, Raimondi does for himself. And he likes the schmoozing, the wheeling and dealing. These are not distractions to him, nor does he accept the notion that the marketplace is to be shunned by the artist lest contact with it corrupt him. Indeed, Raimondi thrives on taking care of the business aspects required by his art.

As Raimondi built *Michael,* named after his close friend Michael Gudiciane, Werner Schumann (then of Guggenheim Productions), commissioned by the National Endowment for the Arts, filmed the sculpture's progress.

Meanwhile Nebraska's bicentennial competition went forward. In April 1975 Raimondi was named among the winners and began planning *Erma's Desire.* He remembers having "zero relationship" with the art world at the time, but this did not trouble him—he had a major project.

It is no surprise that his first big commission is named after his mother. Then as now, Raimondi wears his love for his family on his sleeve. And they, especially his parents, respond in kind. He is emphatically not the alienated artist. Family sustains him, and he, in turn, has celebrated mother, father, and his brothers by naming sculptures after them. As the *Cages and Castles* series moved toward what would be its conclusion, Raimondi named another major work after his father. *Peter John's* three spires, one supported by the lattice of a cage, went up in Milwaukee at the state headquarters of Blue Cross/Blue Shield in 1977. A contingent of Raimondi's family, including his godmother, Evelyn Conry, attended the dedication, as they

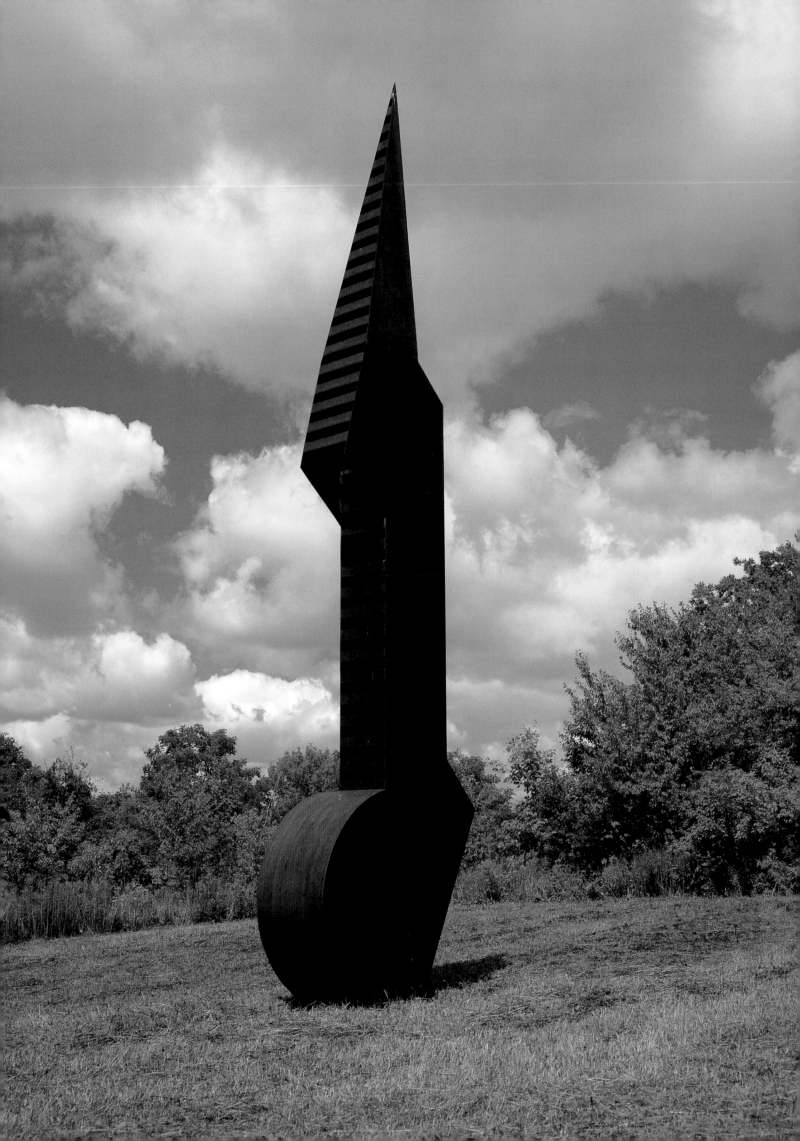

had that of *Erma's Desire.* Whenever and wherever a major Raimondi work is dedicated, the family is there in force. During his remarks, he always salutes them for their sustaining support.

Raimondi moved restlessly through the late 1970s. He left a studio he had in Maine for one in Lawrence, Massachusetts, a working-class mill town off the beaten track. He split with Morel, his first serious lover, who had worked by his side through much of the *Cages and Castles* series. He continued to win competitions and private commissions, and he built pieces in Miami Beach; Burlington, Massachusetts; and San Angelo, Texas. He also visited Palm Beach, Florida, for the first time. In short, Raimondi lived the peripatetic life of a working monumental sculptor. But below the surface his imagination was undergoing a sea change that would not begin to manifest itself until *Zephyrus,* in 1980.

In the late 1970s and early 1980s three decisive changes took place in Raimondi's life. In 1978, just turned thirty years old, he returned to his boyhood home, which was still owned by the family, on Bennington Street in East Boston. He took over the third floor, turning it into a loft, a space he designed to hold his growing art collection and to afford him room for the sort of social life he wanted to become accustomed to. Where Arnold's Hobby Shop had been, he set up a bare-bones studio, relying on a kerosene space heater through the winter.

In 1981 Raimondi met Ralph Cantin, soon to be a graduate student in architecture at Harvard. Cantin had taken a degree in civil engineering at the University of Connecticut and was working as a highway engineer. Both men quickly realized that they had found in the other what they had been looking for and that has been that. Given Raimondi's devotion to his work, his appetite for collaboration, and his need for close personal relationships in work, Cantin's profession was a welcome bonus that has made for a natural fit.

Cantin's entrance into Raimondi's life coincided with the end of *Cages and Castles.* Cause and effect? Not that simple, surely, but the work Raimondi has done since meeting Cantin is that of a freer man. Free of the cage and of the straight line, and free to draw into his imagination the outside, the natural world.

The third change cannot be documented precisely. At some moment Raimondi's life as an art collector, interior designer, and art dealer became one with his life as an artist. Raimondi had built privately commissioned pieces since *JAT,* but now, as more such commissions came his way, Raimondi tended to make friends of his clients. They came to his house for the dinner parties he enjoyed giving, saw the art on his walls, and a number of them responded to what they saw by asking Raimondi if they could purchase it.

Raimondi had begun to collect art in the early 1970s at roughly the same time commissions first came his way. He bought prints by Frank Stella and Roy Lichtenstein, the safe choices of a neophyte. His taste quickly became more adventurous, and as he built his collection he began to see that he did not want to live to make art. Instead he wanted to make and be surrounded by beautiful art. He realized that creating, collecting, and dealing art could coexist. He also understood that to integrate the various elements of his life successfully he would have to break some very simple rules.

The old saw says, Do not do business with friends. Raimondi has done just that for more than twenty-five years with friends he has made through his work as an artist. They come to his Palm Beach home for dinner and might leave having bought a garden version of one of his monumental pieces (Raimondi owns copyright on every piece he has ever made), and since guests are surrounded by the paintings of Gregory Amenoff, Gary Stephan, Brian Rutenberg, George McNeill, and Katherine Porter and various works of African tribal sculpture, their interest might be piqued by one of these. Raimondi is in close contact with the artists, some of whom are friends, and visits their studios frequently to buy work, some of which he later sells to his clients. These sales have augmented Raimondi's income between sculpture commissions, but the relationship is more than business.

Raimondi only deals in art that he loves. He discovered Gregory Amenoff's work in Boston in 1971 and has been a staunch supporter of the artist through the fat 1980s and after, when the art market fell. There is nothing contractual between him and Amenoff, nor is there any more than a handshake between Raimondi and the other artists. Unlike a gallery, Raimondi buys the artist's work before he sells it. The expectation on the artists' part is that their work will fetch a fair price and go to a good home. What makes this unusual is that artists rarely mix these activities: artists make art and dealers deal art. Two separate professions. By combining them Raimondi again goes his own way.

Art dealing has led to some extraordinary relationships and opportunities. Raimondi often functions as interior designer for the collections he helps build. A major example is in Boston's North End at the accounting firm of Vitale, Caturano and Associates, to which Raimondi and his accountant and longtime friend Richard Caturano have brought Amenoffs, Porters, Michael Kesslers, the yellow-red tornado-like Rutenberg behind the main reception desk, and many other works including a number of Raimondi's own drawings and table-top versions of his sculptures. There is art in every office, along every hallway, and most forcefully in the large conference rooms and around the reception desks on the ground floor. The six floors are a secular chapel where art is in the service of businessmen desirous that their taste speak for them. This is not the generic "art" that hangs in many banks and offices. Nor is it art bought with profit in mind. This is art chosen to express a level of attention and care that, the implication is, will be focused on each client. It is art both powerful enough that a client would be likely to say something about it and of an individuality by which a prospective client could judge the firm. On every floor Raimondi has prominently hung tribal shields. Their presence emphasizes the protective nature of accountants from onslaught in the financial jungle.

In 1980 a private collector commissioned Raimondi to create a piece on Nantucket Island. The piece would sit on a low sand dune, the most completely natural site Raimondi had ever been given. The landscape's fragility immediately impressed him, and so did the golden marsh hawks he saw hunting mice and rabbits. They flew so close to the sand and sea grass that their flight paths took the shape of the rolling dunes. In this undulating line Raimondi found the image that he developed into *Zephyrus,* named after the Greek god of the west wind.

While *Zephyrus* is recognizably the work of the man who created *Erma's Desire*, the tense spikiness of that piece has been relaxed. One of Raimondi's signature spires flows out horizontally, mirroring the landscape. What was a latticework cage in *Peter John* is now a row of barrel staves or the ribs of a whale carcass or wrecked ship, descending in rhythm as if progressively more buried in sand. This is a horizontal work whose three rising elements are connected more to the landscape than to the sky. They suggest the hawk's flight, a harpoon raised aloft, and a sail tacking before the wind. *Zephyrus* steps away from and opens out *Cages and Castles,* and *Zephyrus* in turn begat *Aquila,* which begat *Lupus,* which led through *Dian* to *Dance of the Cranes.*

But the inspiration for these new forms did not come from *Zephyrus* alone. While on the island Raimondi happened to read Henry Beston's *Outermost House.* Beston wrote about the world as he experienced it during the year, September 1926 to September 1927, which he spent in a house on land he had bought two miles south of Cape Cod's Eastham Life Saving Station. This was long before ecology was in vogue, and his environmentalism arose out of close observation of a landscape that he loved. Beston held a simple creed: "Nature is a part of our humanity, and without some awareness and experience of that divine mystery man ceases to be." Beston's book underscored and deepened Raimondi's new interest in endangered species. He realized that in his lifetime the American eagle had disappeared from Cape Cod. Beston not only sharpened Raimondi's eye for the natural world but also turned him toward doing work that could speak of his concerns. "I was inspired by Nantucket," he remembered. "A great light went on, it seemed, at my very core. It was an awakening. I felt I was no longer limited to the personal in my work; I could open my heart up to the universe."

Aquila (1981), Latin for eagle, is where the new openness of *Zephyrus* merges with Raimondi's awakened concern for bird and beast. Originally designed for an airport in Anchorage, Alaska, *Aquila* ended up in Miami. It is one of Raimondi's most lyrical and beautiful works, and its site on Brickell Key is near perfect. Viewers can see the work from a distance as they walk or drive across the bridge that spans the key. If they walk along the concrete paths that run beside the key, they can pass it and get a closer look. Bronze *Aquila* balances the horizontal and the vertical, negative and positive space, bird feather and bone. From a distance *Aquila* resembles a carcass thrown up on land by the nearby water. At one end a whisper-thin wing shape rises, all but disappearing into the ether. Seen against the water, *Aquila's* curving A-shapes could be sails, and against the air, feathers. Air and water are in harmony, and forms that appear ancient, fossil-like, have a lyric, modern flow.

Close-up, the sensation is of being amid the remains of something. The slender upreaching sickle wing is evidence of a bird brought down. The sail shapes could be bones sharpened by the action of wind and water. The space between these elements is expressive because it allows one to imagine something larger, some form that could complete the skeleton. But *Aquila* is not programmatic. A viewer might conjure the subtext, "This is an eagle destroyed, a crime in which you are implicated," but Hart Crane's words from the poem "At Melville's Tomb" might

Zephyrus, 1980
Cor-ten steel, 11' tall x 22' x 9'
Phillip and Charlotte Mason, Nantucket Island,
Massachusetts

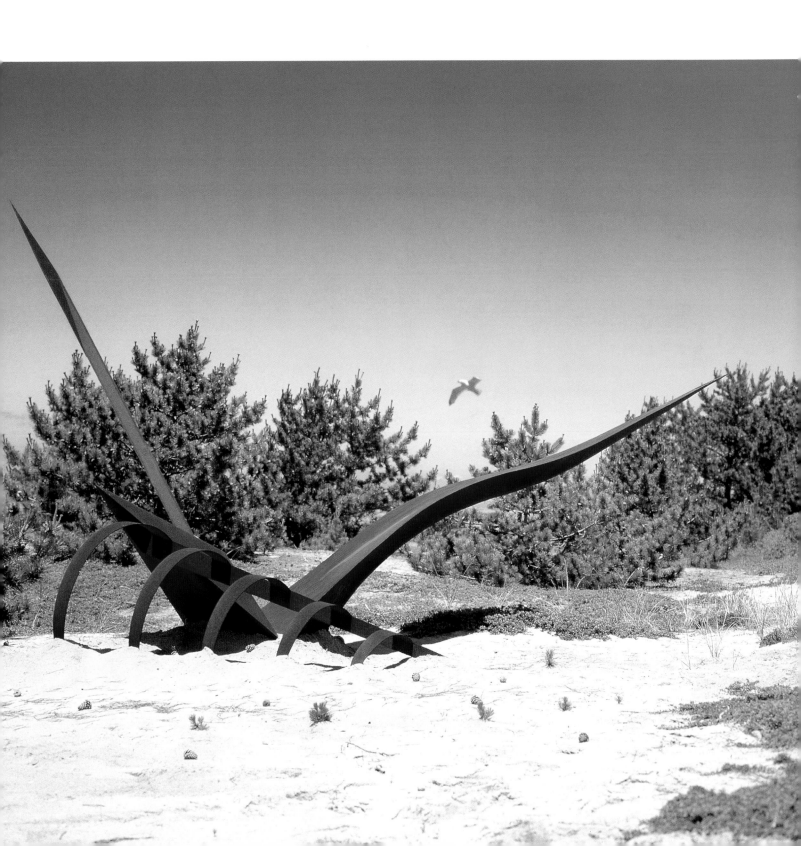

as easily come to mind: "The dice of drowned men's bones he saw bequeath / An embassy." *Aquila*'s ambiguities add to the work's considerable power.

During the creation of *Aquila,* Cantin's engineering skills played an important role for the first time, allowing Raimondi to archieve a new level of precision in his fabricating. Cantin's role needs to be explained because what he did on the piece is now old-fashioned, having been superseded by computers. In a ballroom in a Winthrop, Massachusetts, condominium complex, he drew the pattern for *Aquila* on graph paper spread over a carpet's uneven surface. He worked from a drawing Raimondi had based on the five feathers at the tip of an eagle's outstretched wing. To line up the piece properly and to scale it off, Cantin's patterns were translated first into a model. He had to find the center of gravity for the smallest feather, and then each one that followed had to be 6 percent larger. Cantin then made a cartoon, a blueprint, of *Aquila* at full scale.

At about the same time Cantin completed this painstaking labor, large blueprint machines became available. This meant the pattern for the first feather could be enlarged to specifications by setting a dial on the machine. What had taken hours could now be accomplished in minutes. Today Cantin uses a computer to generate the templates from which patterns are made.

The following year, 1982, Raimondi was awarded a three-month fellowship at the MacDowell Colony in Peterborough, New Hampshire. There he began the drawings of wolves, realistic studies as had been the case with *Aquila,* that became the forty-foot *Lupus,* a work that would not reach its present site at Cambridge, Massachusetts, Lotus Development Corporation until 1985. The commission came through the developer David Carter at Cabot, Cabot & Forbes. (Like most monumental sculptors, Raimondi prefers to work directly with developers. Unlike architects, developers *always* get their way.)

Lupus sits in an out-of-the-way location on the terrace of the Lotus building three stories above a little-used access road that runs beside the Charles River. It can partially be seen from the road but is visible from the top floors of Lotus, surrounding buildings, and, at a distance, from the Charles. Indeed, Raimondi celebrated the dedication of *Lupus* by throwing a party aboard a hundred-foot yacht that cruised within sight of the sculpture.

Despite the difficult site, *Lupus* is one of the few monumental sculptures whose backdrop is an entire city. Once you climb to it, you see this Cor-ten wolf against Boston's financial district, Beacon Hill with the State House's gold dome, Back Bay, and, in the far distance, the Blue Hills. This big world emphasizes the wolf's isolation in it, an isolation the wolf seeks because, although man may be his only predator, he is relentless.

Lupus foreshadows Raimondi's figurative work that begins in earnest at the end of the 1980s. Unlike *Zephyrus* and *Aquila,* it is vertical, a howling wolf, head raised skyward in full-throated cry. Below the spear-point muzzle with its curled pennant of hair, the wolf fills out and becomes maternal. At the base, its tail curves, fanning out like a ramp one can walk up, entering a shallow cave, the sort a mother makes by drawing her young in to shield them with her body. The animal's back and shoulders are

bunched and muscular. *Lupus* is coiled to protect, and yet, as with so many of Raimondi's sculptures, the viewer's eye must go up, and as one's neck arches he takes on something of the wolf's posture and becomes, briefly, one with the beast.

Throughout this run of work Raimondi anchored his explorations in realistic drawings. He is a consummate draftsman who has routinely polished his drawings to a high degree of finish so that even those that are studies qualify as independent works of art. In working on *Lupus* and the others, Raimondi sought to draw out of the appearance of the thing an essential gesture. He began by placing a mirror to nature, but to succeed on his terms, he had to go beyond the image this mirror gave him. He aimed to seize what is vital in nature by the concentrated attention and grace of art.

Raimondi strives for beauty for its own sake, because he believes we will be inspired and instructed by the beautiful. If we admire the wolf's muscular lines, the eagle's feathers in flight, or the marsh hawk's shadowing the Nantucket dunes, our better instincts might lead us to protect these creatures. Raimondi did not stop at using art to advance his purpose; he joined Defenders of Wildlife and served for nine years on its board, several as director of development.

These "endangered species" works, in the form Raimondi came to call "romantic abstraction," culminated in *Dance of the Cranes,* arguably Raimondi's most significant work to date. This was not only his biggest commission but also his tallest piece, for which he received more attention than he previously had known. While *Dance of*

the Cranes was being made, Raimondi and Cantin moved to Palm Beach, Florida, where they live today.

Once there his absolute faith in himself and his work asserted itself. He remembers being off Manalapan Island, south of Palm Beach, on a boat ride when he spied the peaked copper roof of a house made of coral stone, very contemporary materials for Palm Beach. He imagined that whoever lives in that house ought to be interested in his work. When he contacted the owners he turned out to be right, and today a fifteen-foot version of *Lupus* has a perfect site—a mass of sea grapes to one side, beach grass at its base, and the green-lavender ocean for a backdrop.

These garden versions of Raimondi's larger works are not models. To be produced in limited editions of three, they must be works of art in themselves at this height. While he still seeks out private commissions for new works, he is equally passionate about finding different settings for existing images. He has said, "I would rather take the approach of Brancusi who died with 78 works in his lifetime than David Smith who died with 780 works in his."

Within a year of moving to Palm Beach, and *Aquila* and *Dance of the Cranes* having been installed, Raimondi's work veered in a new direction. *Spirit Ascending* (1988) is the bridge. The figure stands with arms raised in a victory V, triumphant. But the figure is headless, and, from some angles, the legs and torso could be a tree trunk. The V-shaped exultant branches thus suggest that a force of nature has triumphed. The thirty-nine-foot version of *Spirit Ascending,* although the design was a finalist in a national competition, found its first home, not figuring prominently into the image of some American city, but

on the private lawn of a Palm Beach collector, where it stood gleaming and golden against towering dark green tropical hedges.

Athleta followed *Spirit Ascending;* its figuration evolving naturally as Raimondi intuited that it would. Both pieces raise arms to heaven. The spires of Raimondi's early work are now human in form. During his free time while in Kearney, working on *Athleta,* Raimondi conceived *Artorious* (1989), a forty-one-foot version of which stands today in London's Stockley Park, Heathrow.

Artorious (Raimondi's name for the legendary King Arthur) is related to *Spirit Ascending* in that the figure is there but also not there. The Cor-ten steel has been worked so that at the figure's knees, breast, and arms cone shapes protrude, suggesting armor. *Artorious* is hooded, returned from the Levant in disguise. The head is shaped in outline, and the viewer sees cloud and sky there and at the throat. *Artorious* is the ghost of Arthur, and the English clouds and sky are his spirit. The arms, joined overhead holding Excalibur pointed toward the sky, outline a diamond of air. This emphasizes the hood's downward tilt. *Artorious* raises the sword in supplication preparatory to plunging it back into the rock. In the work's height and gesture the legend goes on forever.

Athleta spawned another goddess, *Grace* (1990), meant to be sixty-eight feet tall, but which at present exists only as a maquette and in garden scale. For Raimondi *Grace* recalls his onetime close friend Grace Hartigan, a painter he very much admires. But *Grace* is not a portrait. Although *Grace* has great gams, thighs, and a beautifully rounded and tucked-in butt, Raimondi's realistic woman ends there. Her upper body rises in sensuous, wind-lifted curves. The feminine and alluring forms of her lower body morph into a wilder manifestation of grace. The Apollonian is topped by Dionysian flames that resemble tendril and leaf forms.

By this time Lippincott's had closed, and Raimondi began to work with Milgo-Bufkin. Their shop, in Brooklyn's Greenpoint section, originally built truck bodies, but under Bruce Gitlin, son of the founder, the company has become the nation's premier fabricator of metal for architectural details. Because of his interest in art and the pleasure he got from working with artists, Gitlin gradually began fabricating sculpture for Frank Stella, Claes Oldenburg, and Richard Serra, among many others.

Today about 10 percent of Milgo-Bufkin's business involves sculpture. In its hangarlike factory there are massive metal bending machines whose size belies their hair's-breadth accuracy, a computerized power shear that functions like a gigantic pair of scissors, a computer command post where all manner of specifications can be generated, and a fifty-foot-long laser machine. This cuts bronze to one thousandth of an inch so quickly that the metal does not get hot to the touch. Through this technology, Raimondi can obtain edges as fine and supple as a pencil line. As before, his maquette is made of cardboard, glue, and cellophane tape. After the metal has been cut and shaped, it is assembled under the direction of Alex Kveton, a sculptor from Prague who is in charge of the art shop. One reason that Raimondi no longer feels the gut-churning anxiety over a work in progress that he remembers feeling as a younger man is that Milgo-Bufkin is so painstaking and thorough.

Eurus (1990), named for the Greek god of the east or southeast wind, takes the upper half of *Grace* into the realm of pure abstraction. We see the wind as bronze ribbons of flame or smoke, flooding up from a curled base similar to that of *Lupus.* As the bronze work rises, Raimondi plays with negative space as he did in *Aquila.* The wind is in the curved space set off by the twined and parting ribbons. *Eurus* resembles a woman's windblown hair riding in a convertible with the top down. A seventeen-foot garden version of *Eurus* stands in the village of Hagenbrunn, Austria, a suburb of Vienna. It is the largest of seven works, built by sculptors from around the world, in a sculpture park that celebrates the "seven stations of life."

Raimondi's next major work, *Pyre* (1992), has had a life that is as yet unfulfilled. *Pyre* is the most political and, therefore, most problematic of commissions: a Holocaust memorial. The site is Manhattan's Battery Park, where a Holocaust museum opened in 1997. Adjacent to this will be a garden, and it is here that *Pyre* is meant to stand. Complications have arisen over who will underwrite the design, creation, and maintenance of the garden, and there has been little or no progress for a maddeningly long time. Today *Pyre* is in limbo, existing as a maquette and an eighteen-foot model in the sculpture garden of Raimondi's Palm Beach house.

Several years ago the painter R. B. Kitaj showed a group of paintings in New York that employed a long, tapered chimney as the symbol of Jewish martyrdom. Kitaj based the image on those chimneys at Auschwitz, Belsen, Dachau, and elsewhere, through which Jewish souls can be imagined rising to heaven as smoke from the death factories' fiery ovens. In the exhibition catalogue, Kitaj noted that the cross as a symbol of Christian martyrdom had not come into general use until nearly three hundred years after Christ's crucifixion. In a corresponding delay, almost fifty years after the end of World War II, Kitaj's imagination seized on the chimney, and now he offered it as a possible symbol. In *Pyre* overcoats, like those worn by Jews shipped to the camps in freezing cattle cars, ascend to heaven like smoke. The design is simplicity itself. It will remind those who saw Claude Lanzman's film *Shoah* of the heaps of gold teeth, shoes, suitcases, and clothes stripped from the soon to be murdered Jews. *Pyre* also resembles a day's catch of fish being pulled up by the line that has been threaded through their gills. On reflection the viewer might think of Chagall's shtetl Jews shown flying through the sky in his paintings. At Battery Park it will recall for some Alfred Stieglitz's photograph *Steerage* and the Jews wrapped in overcoats who entered America at Ellis Island. For Raimondi, *Pyre* came of its own volition, arriving with sudden, inevitable rightness.

He is eager to see it full scale. At eighteen feet, *Pyre* is not tall enough to achieve the effect of the overcoats rising heavenward. If *Pyre* is ever executed at its projected height of seventy-two feet, the viewer will have to look up as the mass of rumpled coats diminishes as they rise. Even *Pyre*'s present size is capable of eliciting extreme responses from viewers. Twice, guests of Raimondi's have responded to it with tears. In both instances, they walked into his garden knowing neither the work's title nor its purpose, and on seeing it began to cry. One of them was a Vietnam veteran who became so distraught that his wife returned to the house and asked Raimondi's aid in help-

ing calm him down. Will *Pyre* have this sort of power at Battery Park? It may well be Raimondi's great work, but until it stands there no one can say.

In that same year, 1992, Raimondi's *Bravo,* a group of figures—singer, dancer, conductor, instrumentalist—joined in performing motion came to stand at the University of Richmond in Virginia. This is not where Raimondi expected it to be. He had entered a model of *Bravo* in the national competition for the Kravis Center in West Palm Beach, but he was not awarded the commission. The collector Ed Eskedarian saw the model and knew at once that *Bravo* would be just right for Richmond's Performing Arts Center and so made a gift of it to the university, to Raimondi's great satisfaction. The vagaries of monumental sculpture are such that a good home, no matter how arrived at, heals many a wound acquired along the way.

Bravo recalls *Athleta,* but the figures have not been fused into one. Instead, they have been separated yet merged so as to make a freestanding curtain. They move fluidly across their space, in harmony, having reached that moment in performance when all involved breathe as one. The Richmond site is excellent in two regards. There is constant pedestrian traffic, and the backdrop, brick collegiate buildings, not only helps the twenty-eight-foot *Bravo* to achieve the presence and force of a larger work, but its dashing newness against the old buildings produces an invigorating clash.

The lyric lilt of these works informs *Sarah* (1993) and *Ceres* (1994). Since *Dance of the Cranes* Raimondi has returned again and again to the female form as if enthralled. You can see how he traces a full, fleshy amplitude in the rounded, abstract *Ceres* and in the stride of *Sarah, Sarah* after Sarah "Sassy" Vaughn, the jazz vocalist with an opera singer's chops. *Ceres,* Roman goddess of agriculture, is earth-mother thighs supporting delicate new spears of grass. She diverges from Raimondi's figurative work of the past decade in the stunning simplicity of the two elements, primal and elegant, he has combined.

Immediately after *Ceres* Raimondi returned to the figure. *Tigris* (1995) is his most realistic sculpture, a sleek beast that resembles nothing else he has made. It does, however, recall the realistic drawings on which he based *Dance of the Cranes, Lupus,* and *Aquila. Tigris* thrusts upward with a muscular, propulsive force, under control and set to spring. Categories now mean nothing to Raimondi. His confidence allows him to move freely from representation to abstraction, to go wherever his muse will take him.

The force of these recent works is horizontal yet contained in different ways. *Ceres* stretches toward the spring sunlight, a force newly, but not completely, awakened. A glance catches the rampant tiger in Raimondi's *Tigris,* the work is that quick, but you have to slow down and discern the goddess in *Ceres.* As with the cranes in *Dance of the Cranes* or the eagle in *Aquila,* the viewer must let his eye follow a curve to its lyrical conclusion.

* * *

That serene and blessed mode
In which the affections gently lead us on.
—William Wordsworth

Early in his career, in a newspaper article and again in a lecture, John Raimondi quoted David Smith's words, "When we speak of the creative artist we must speak of

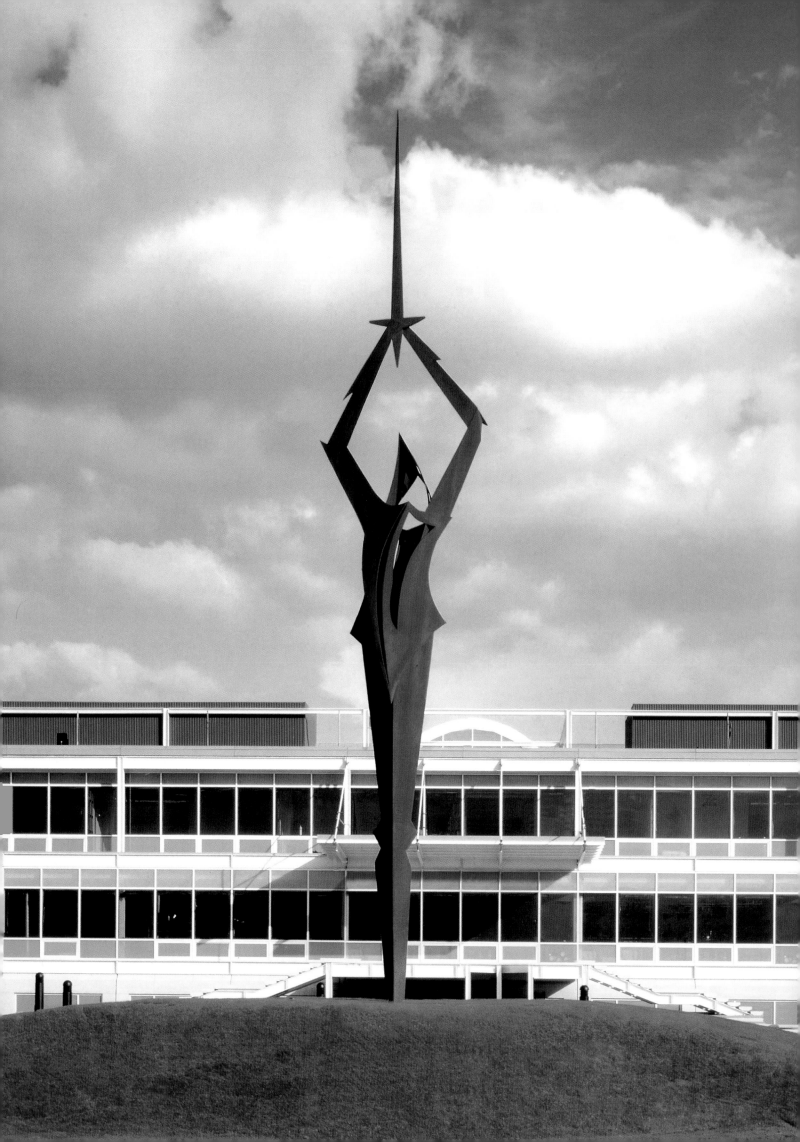

Artorius, 1989
Cor-ten steel, 41' tall
Stockley Park, Heathrow, Glaxo Wellcome,
Uxbridge, England

affection." Thirty years on, and even more so than during the *Cages and Castles* series, so many of which were named after those who stood first in Raimondi's heart, Smith's words speak for the essential spirit of Raimondi's art. It is fair to say that Raimondi has felt his way. Any intellectual construct or aesthetic theory that avoids the motive power of feeling will not adequately address his work. Raimondi considers himself a romantic in the most basic of senses; he is moved to do what he does by the intensity of his affection for his art and for the world as he encounters it.

This intense affection has been felt by all who have worked with Raimondi. It is the catalytic ingredient he brings to collaboration, and what he hopes will come to him, doubled, in return. This is not to be arrived at by argument or analysis but by exploration and the willingness, as Wordsworth puts it, not to lead, but to be led. In his determined way Raimondi has arrived at a body of work, not by developing and refining a signature style, but by trusting the intensity of his affections to gently (and not so gently at times) lead him on.

His affections have been balanced, given weight and force, by what Smith, thinking of his own drive, described as "belligerent vitality and conviction." Not belligerent meaning hostile, but aggressive, a fighter in the service of his art. This remains true of Raimondi today, whose conviction is large enough to keep him dreaming of worlds to conquer even after he has realized so much of the success he sought. "Raimondi works for both," Harry Rand wrote in 1986, "the public space and the private aristocratic setting." True then and true today. And Raimondi does so unabashedly, confident in his ability to project in bronze and steel, at great height or small, the nature of his affection.

Cage, 1971
Cor-ten steel, 18' tall x 26' x 4'
University of St. Thomas, St. Paul, Minnesota

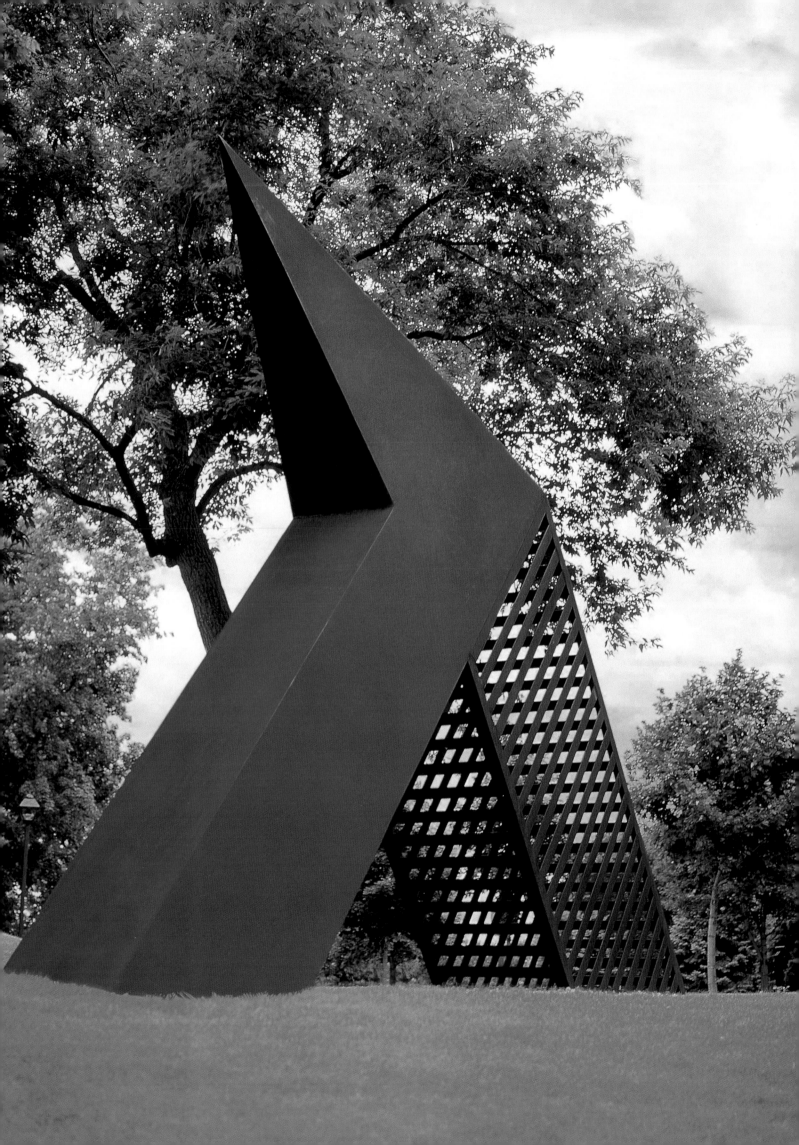

opposite:

Cage, 1971
Bronze, 8' tall x 11'6" x 1'8"
Private collection, West Palm Beach, Florida

Cage, 1971
Bronze, 18" tall x 26" x 4"
Butler Institute of American Art, Youngstown, Ohio

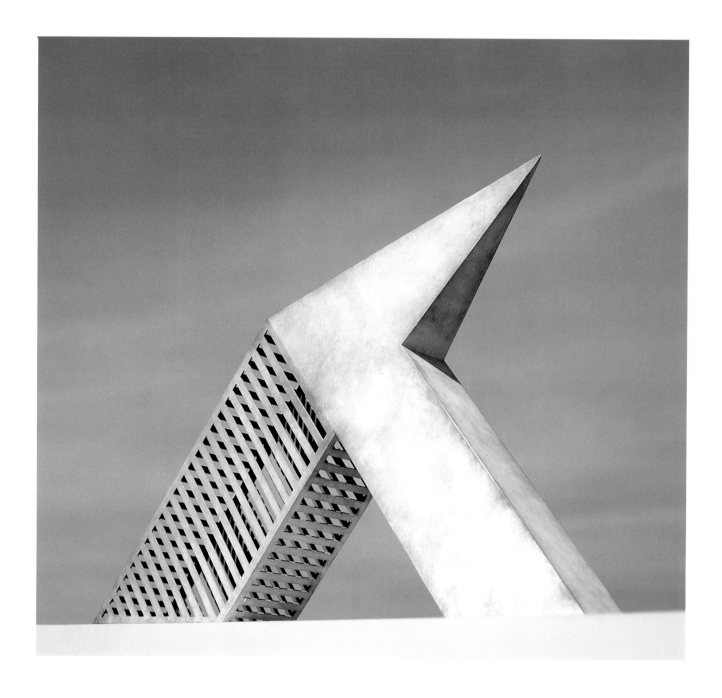

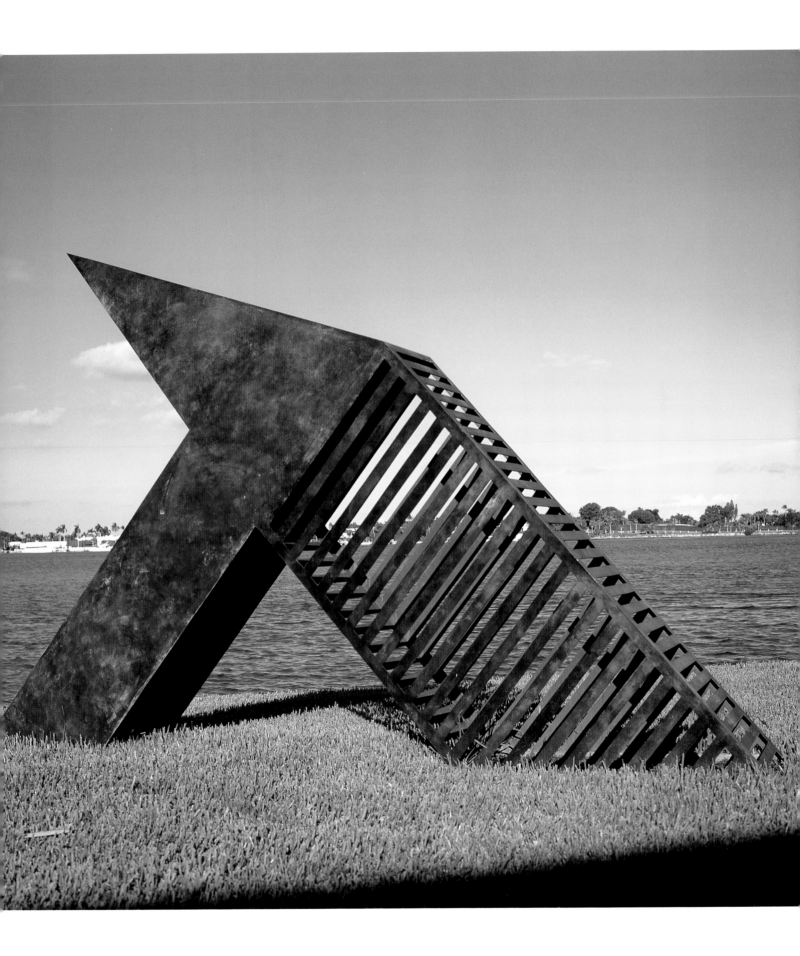

opposite:

David, 1972
Cor-ten steel, 20' tall x 15' x 1'3"
Northfield Mt. Hermon School, Northfield, Massachussetts

Christopher, 1971
Silvered bronze, 16" tall x 24" x 2"
David and Kai Fleming-Wood, Colorado Springs, Colorado

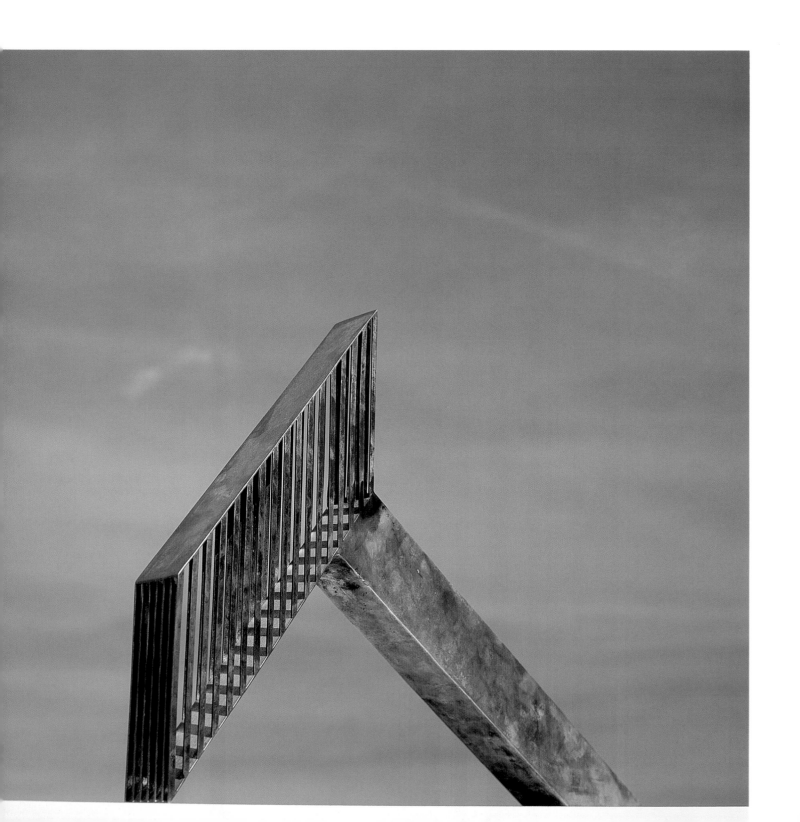

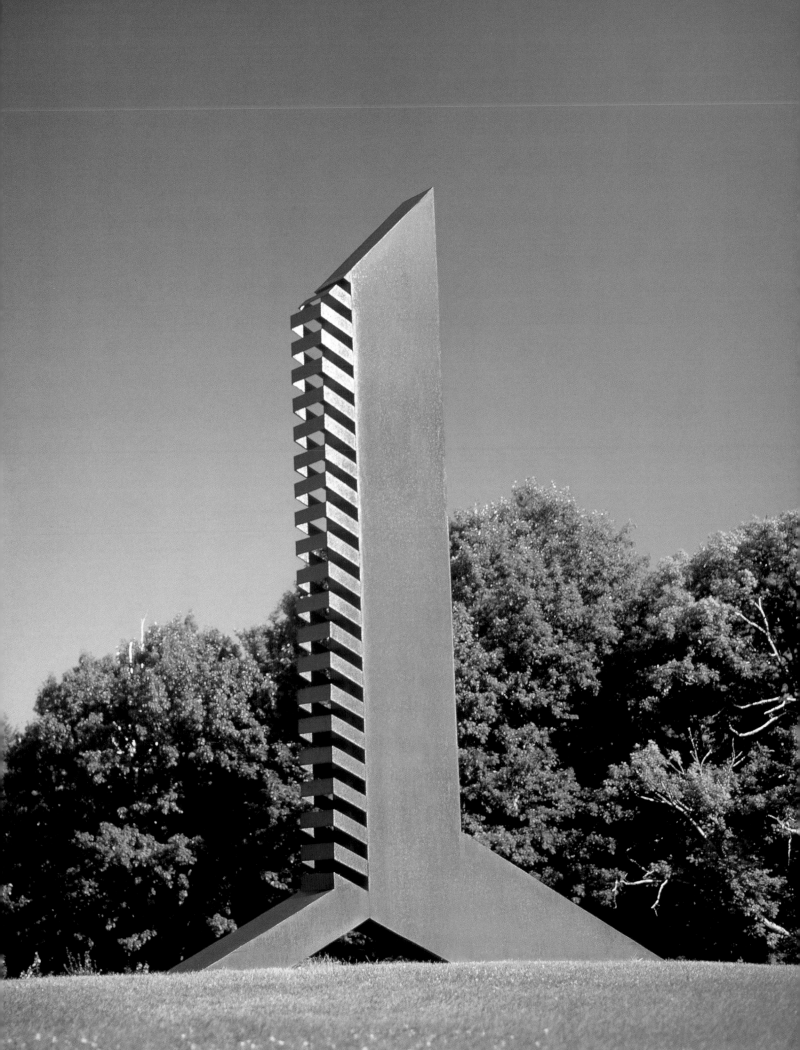

opposite:

David, 1972
Cor-ten steel, 20' tall x 15' x 1'3"
Northfield Mt. Hermon School, Northfield, Massachussetts

David, 1972
Bronze, 20" tall x 15" x 1 ¼"
Institute of Visual Arts, University of Wisconsin
at Milwaukee

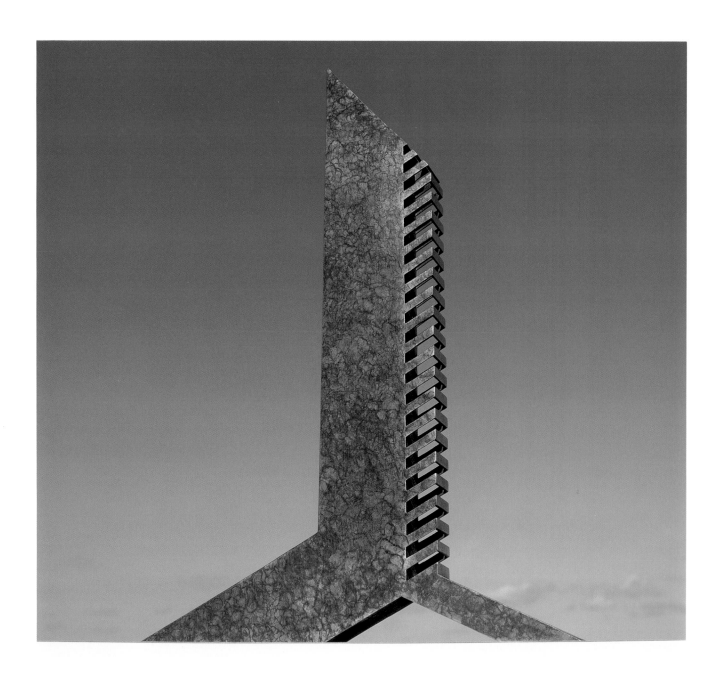

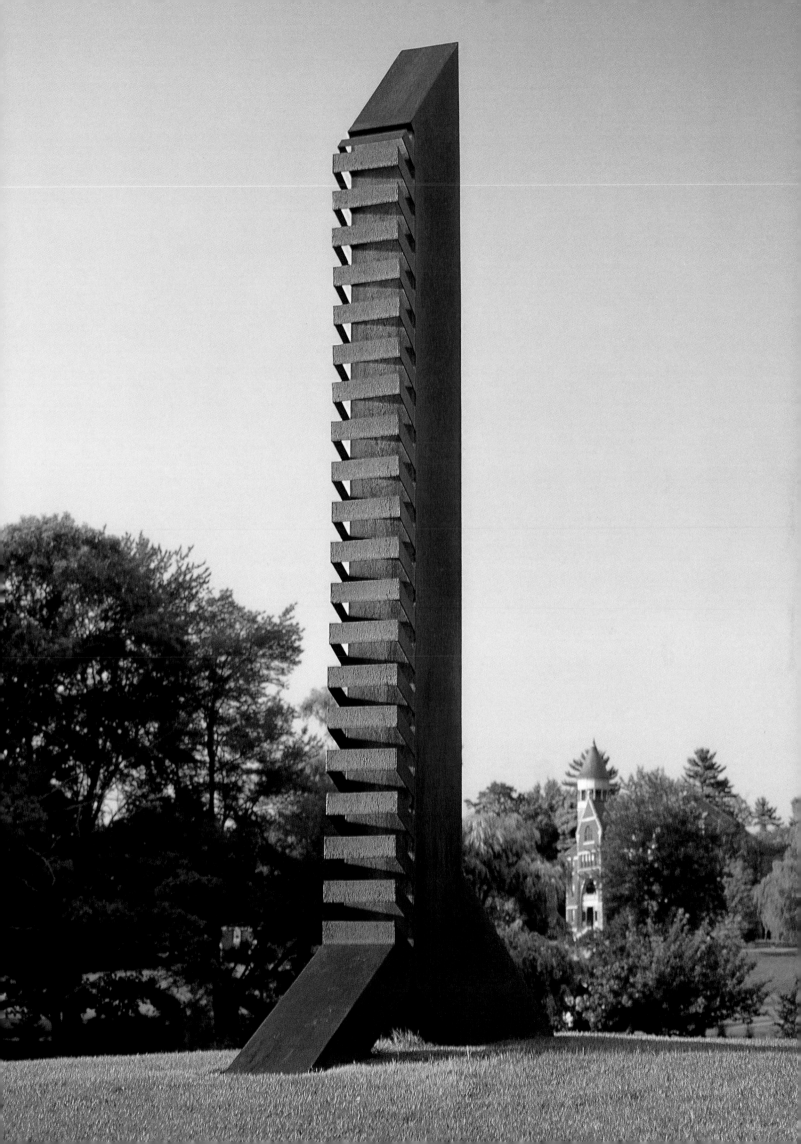

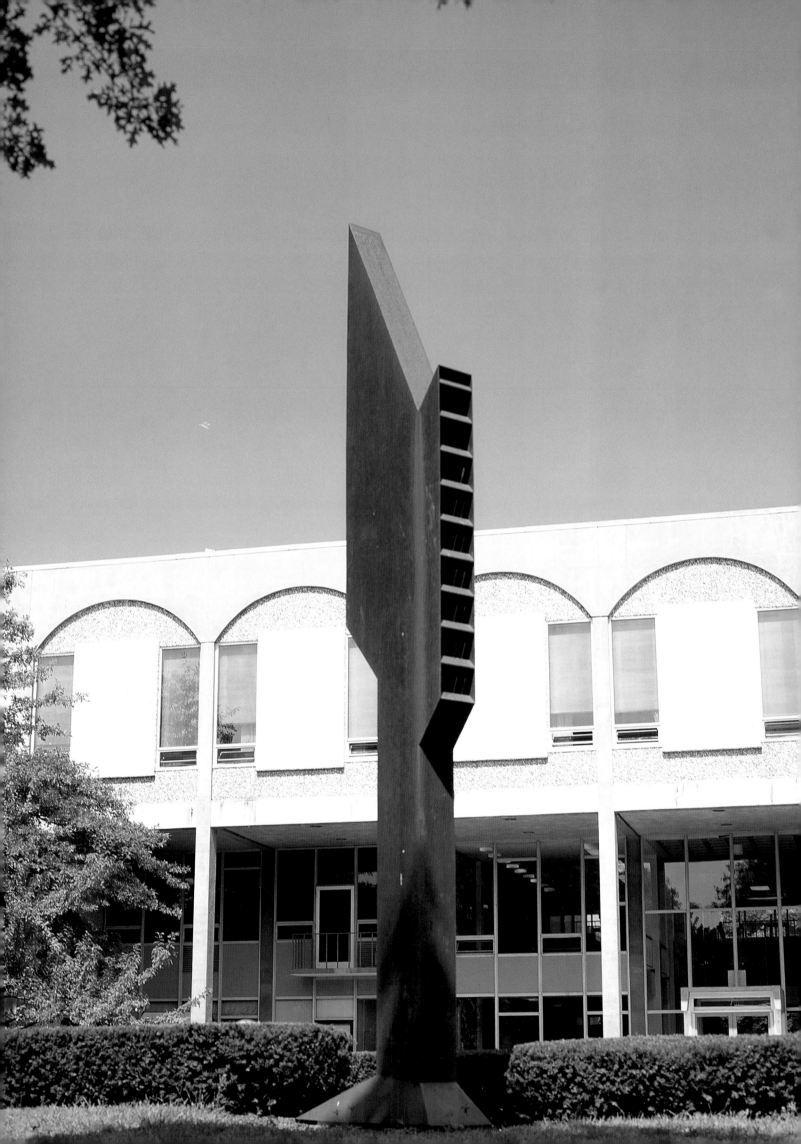

opposite:

Nod, 1972
Cor-ten steel, 20' tall
Bridgewater State College, Bridgewater, Massachussetts

JAT, 1973
Bronze, 30" x 6½" x 2"
Norton Museum of Art, West Palm Beach, Florida

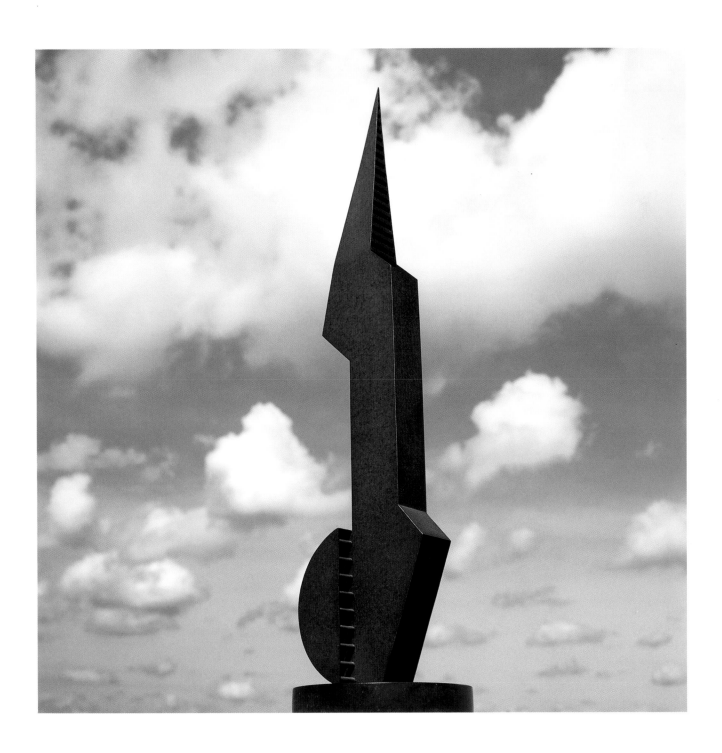

opposite:

JAT (detail), 1973
Cor-ten steel, 30' x 6'6" x 2'
Butler Institute of American Art, Youngstown, Ohio

JAT, 1973
Bronze, 10' tall x 2'2" x 8"
Max and Cil Draime, Palm Beach, Florida

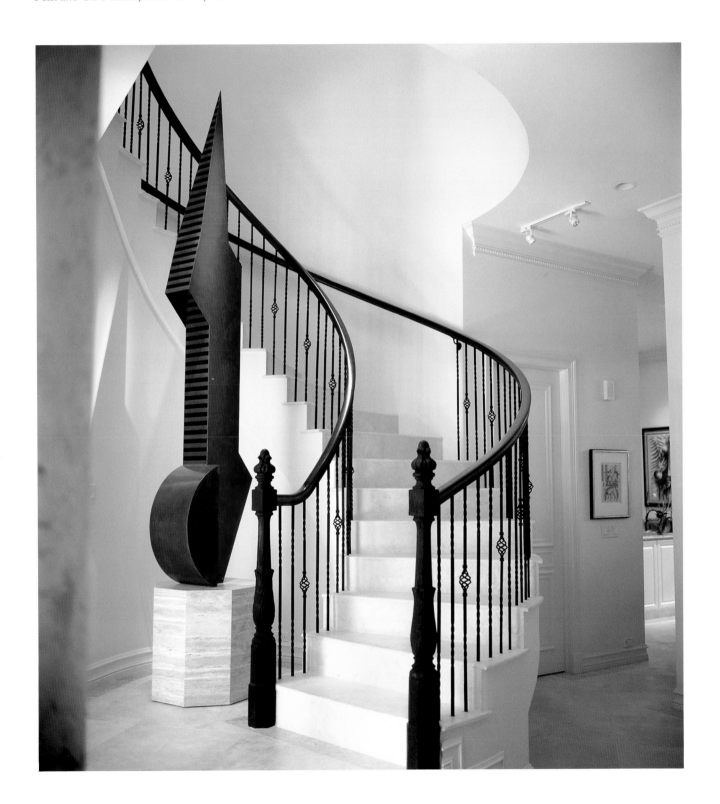

Michael, 1974
Cor-ten steel, 18' tall x 27' x 12'
Commissioned by Canal National Bank,
Donated to the City of Portland, Maine

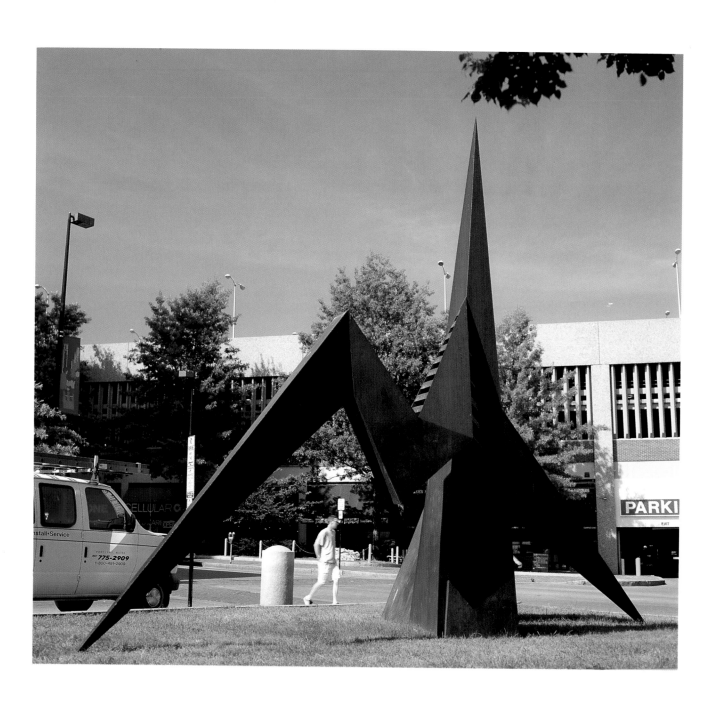

Michael, 1974
Cor-ten steel, 18′ tall x 27′ x 12′
Artist-in-Residence, Works in Progress, Sponsored by
Institute of Contemporary Art, Boston City Hall

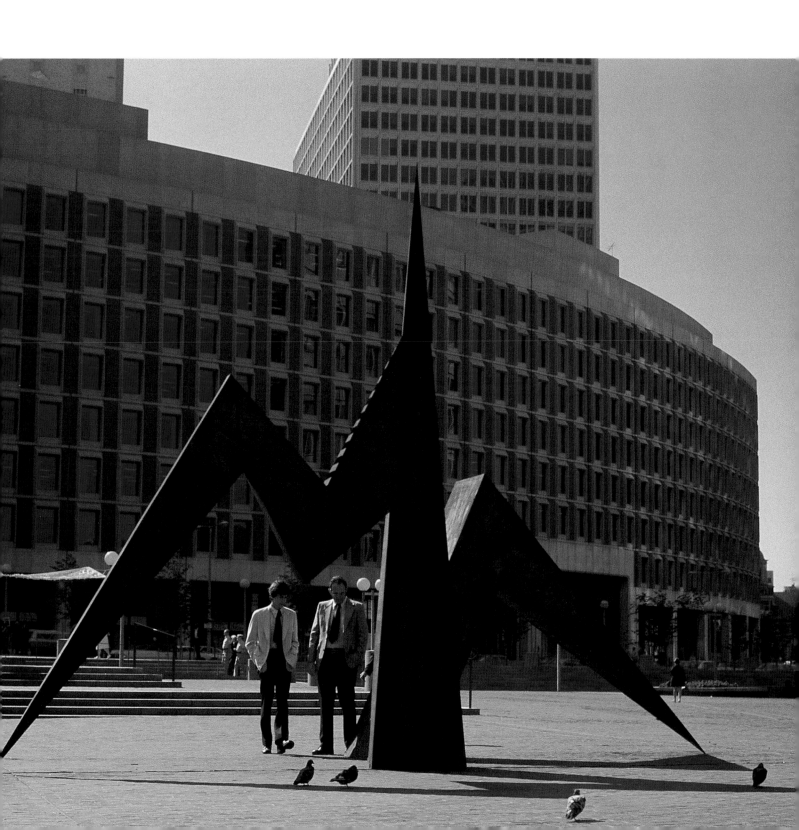

opposite:

Evelyn, 1978
Cor-ten steel, 7' tall x 14' x 7'
IBM, Burlington, Massachusetts

Stephen's Summer, 1973
Cor-ten steel, 18' tall x 50' x 24'
Dolly Fiterman, Minneapolis, Minnesota

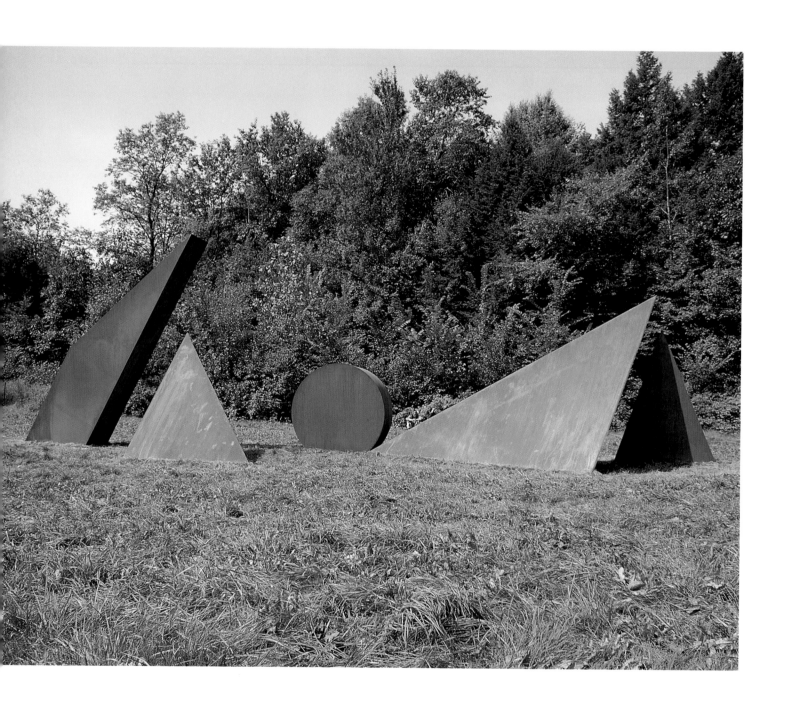

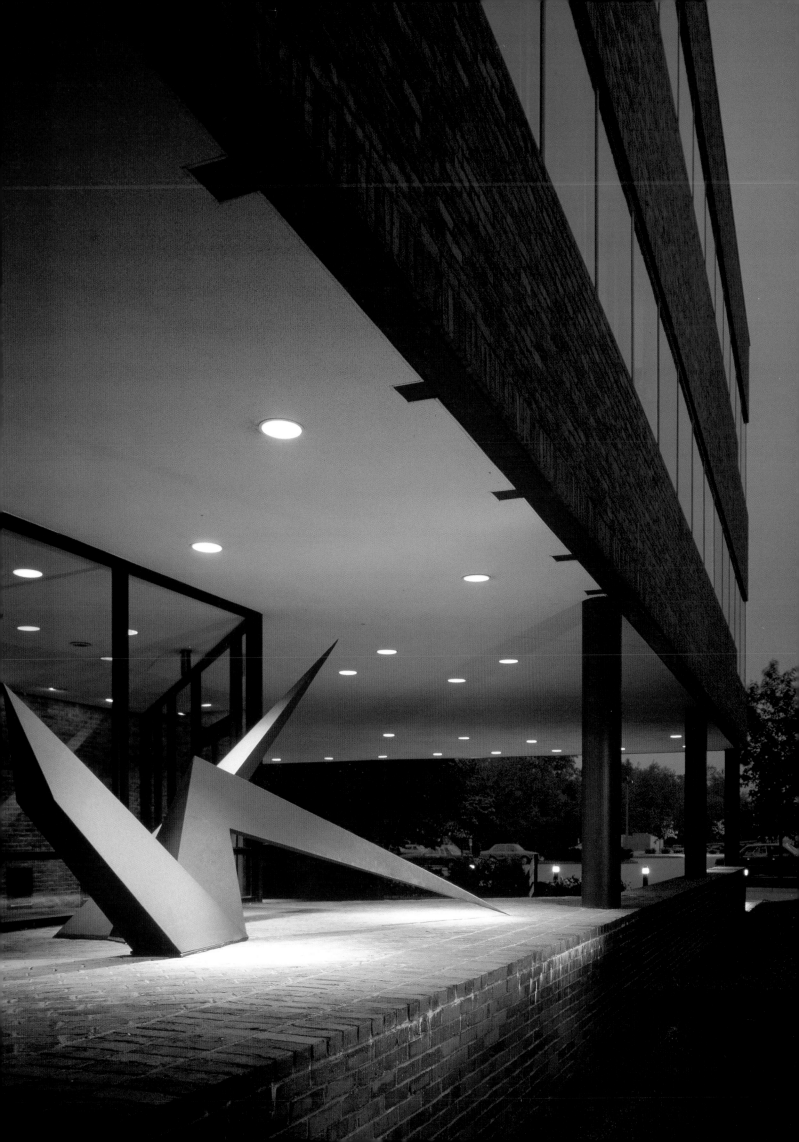

Erma's Desire, 1976
Cor-ten steel, 26' tall x 47' x 33'
I-80 Bicentennial Sculpture Project, Grand Island, Nebraska

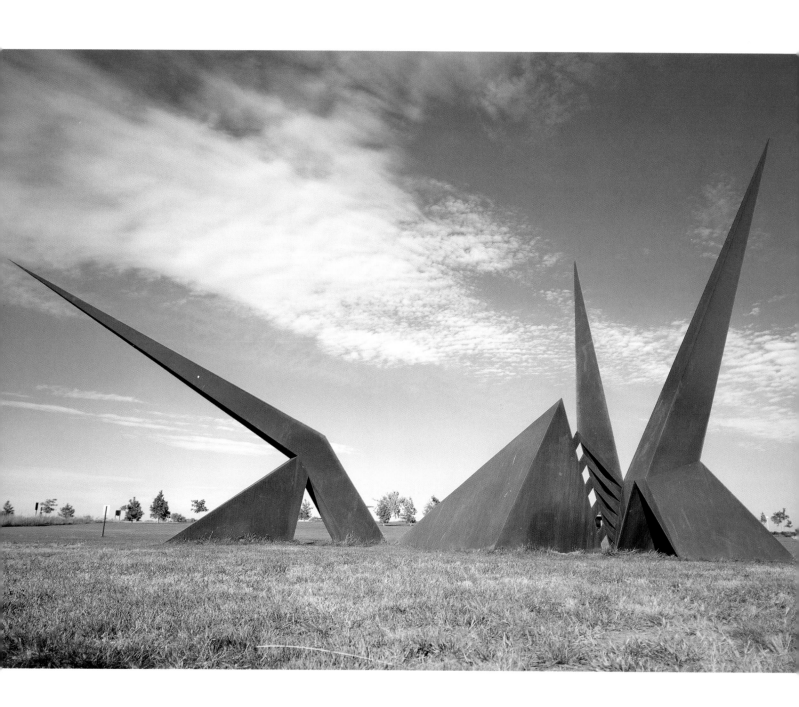

Erma's Desire, 1976
Cor-ten steel, 26' tall x 47' x 33'
I-80 Bicentennial Sculpture Project, Grand Island, Nebraska

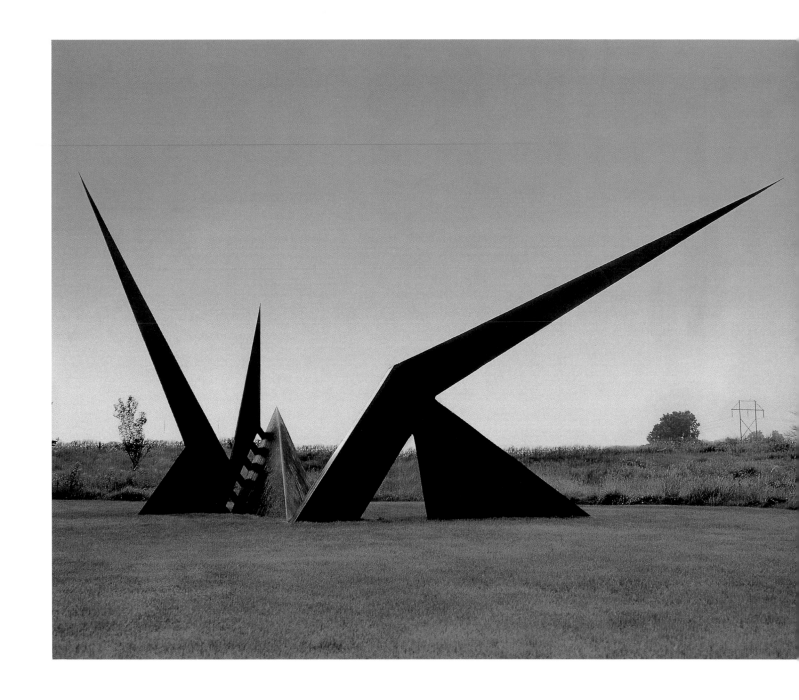

opposite:

Peter John, 1978
Cor-ten steel, 36' tall x 44' x 18'
Blue Cross/Blue Shield Headquarters, Milwaukee, Wisconsin

Peter John, 1978
Bronze, 36" tall x 44" x 18"
Milwaukee Art Museum, Milwaukee, Wisconsin

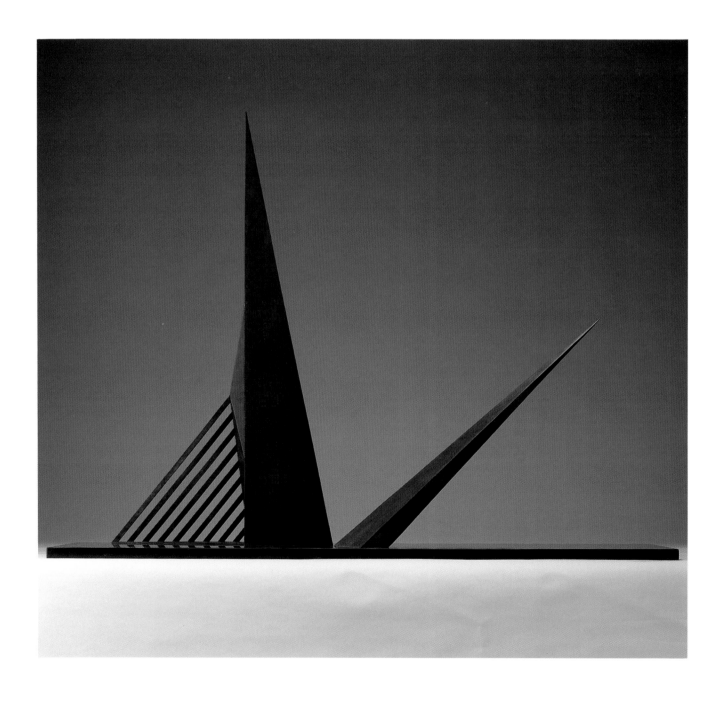

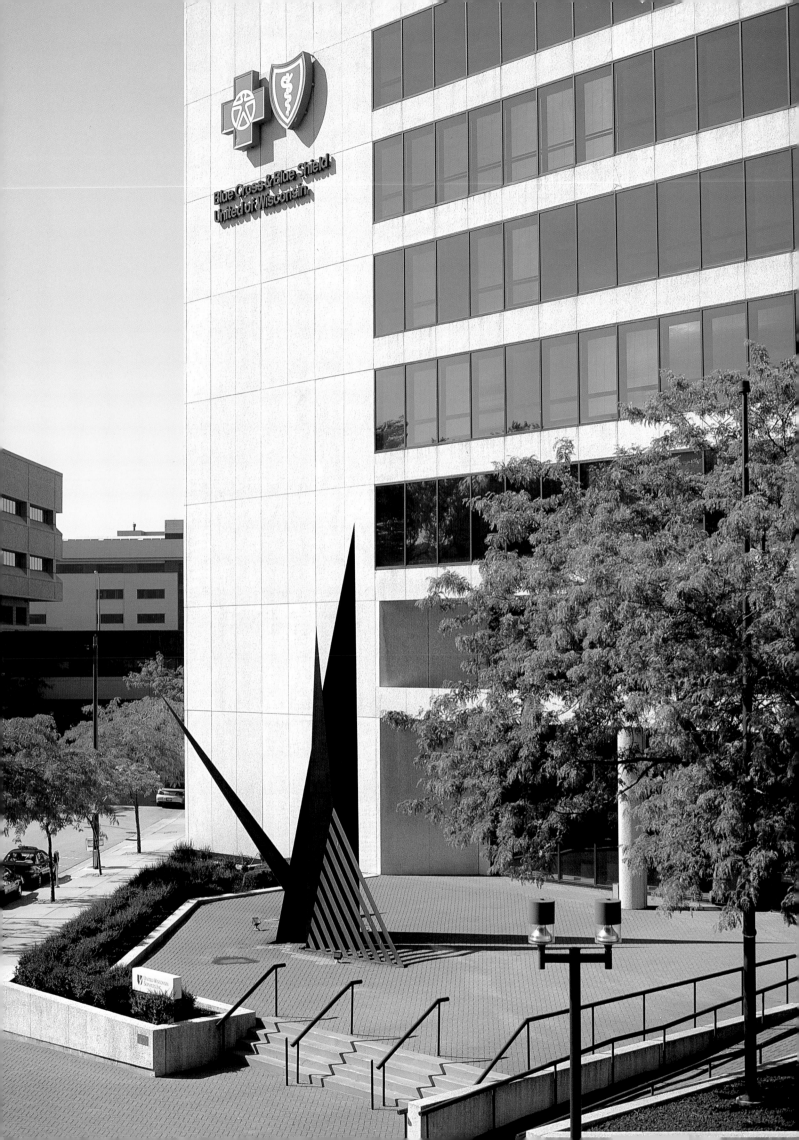

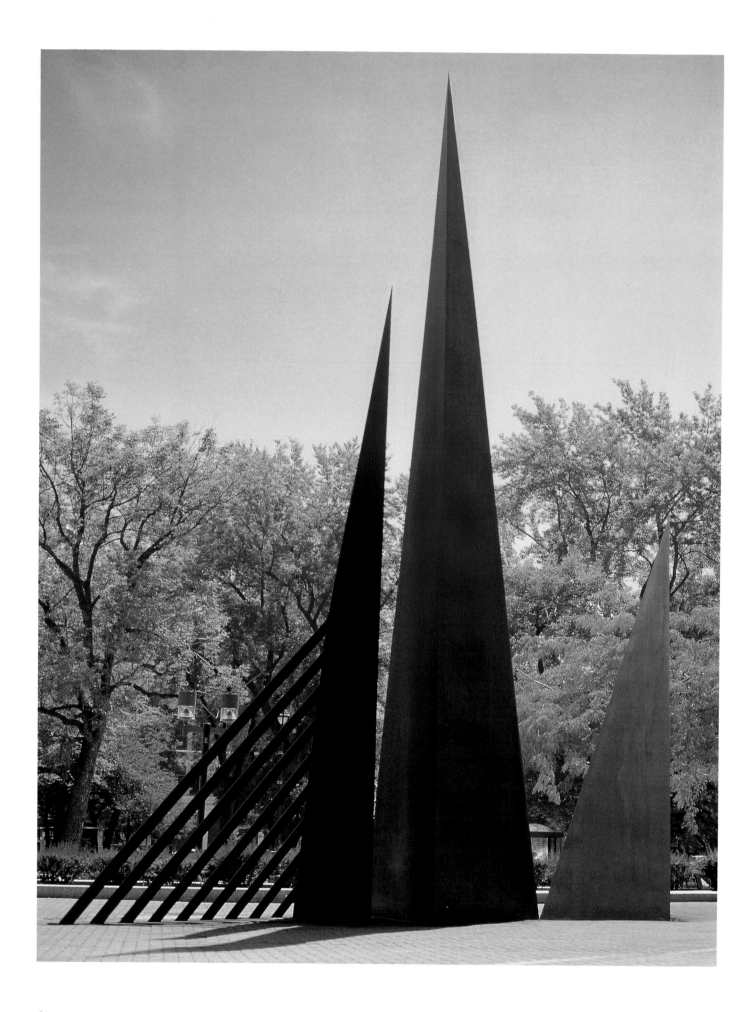

opposite:

Peter John, 1978
Cor-ten steel, 36' tall x 44' x 18'
Blue Cross/Blue Shield Headquarters,
Milwaukee, Wisconsin

above:

Eleven Lines (Study for *Peter John*), 1977
Ink on paper, 18" x 14"
Columbus Museum of Art, Columbus, Ohio

Study for *Ran*, 1979
Ink on paper, 8" x 10"
Williams College Museum of Art,
Williamstown, Massachusetts

Ran, 1979
Cor-ten Steel, 28' tall x 42' x 16'
Civic League Rose Garden, San Angelo, Texas

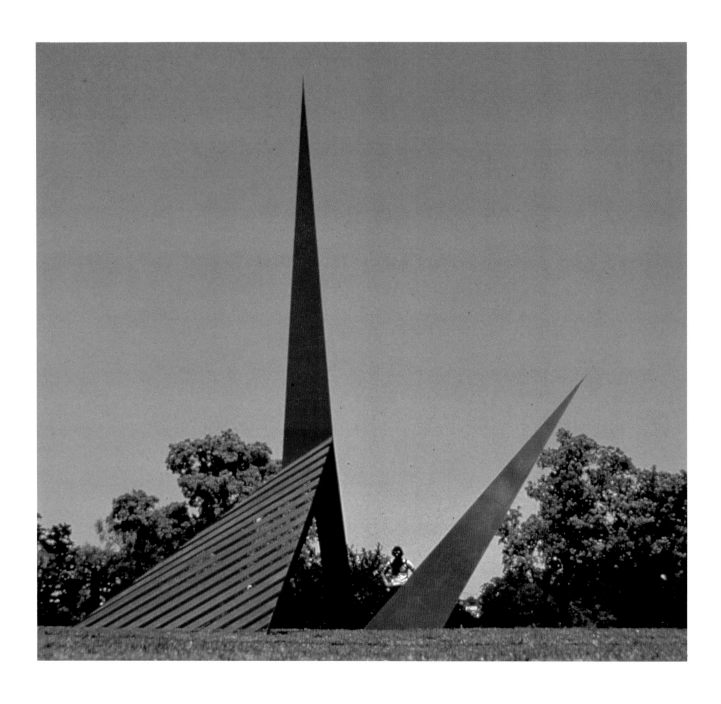

Ran, 1979
Cor-ten Steel, 28' tall x 42' x 16'
Civic League Rose Garden, San Angelo, Texas

Equueleus, 1980
Cor-ten steel, 12' tall x 25' x 8'
Palm Beach Community College, Lake Worth, Florida

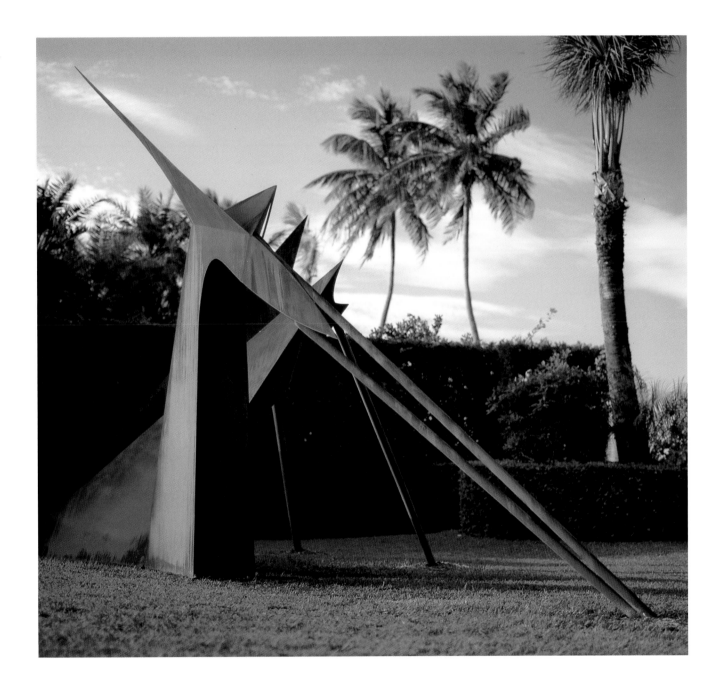

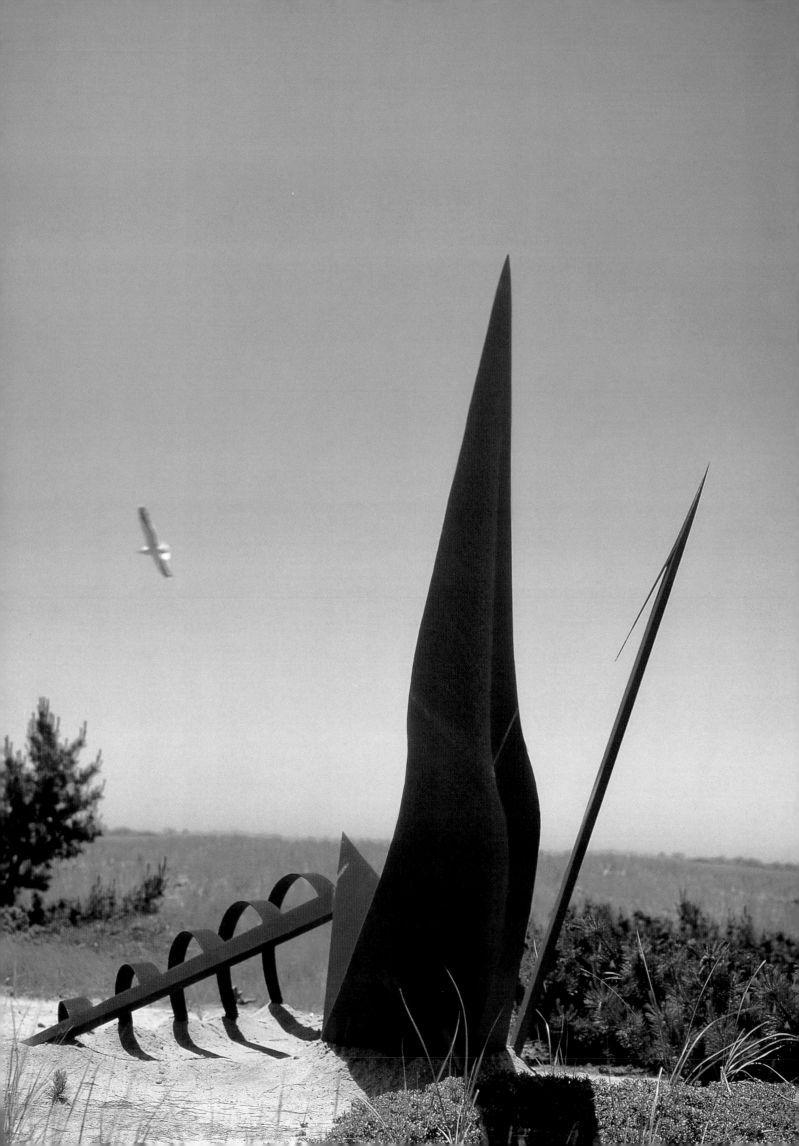

opposite and below:

Zephyrus, 1980
Cor-ten steel, 11' tall x 22' x 9'
Phillip and Charlotte Mason, Nantucket Island,
Massachusetts

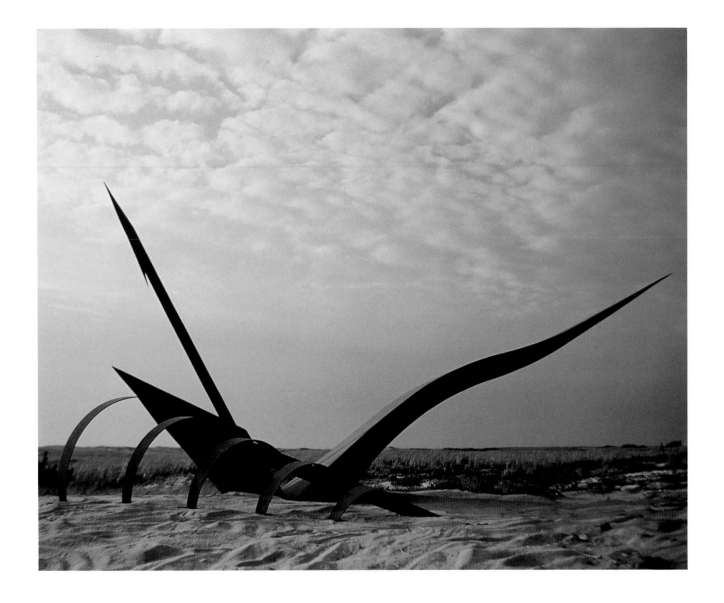

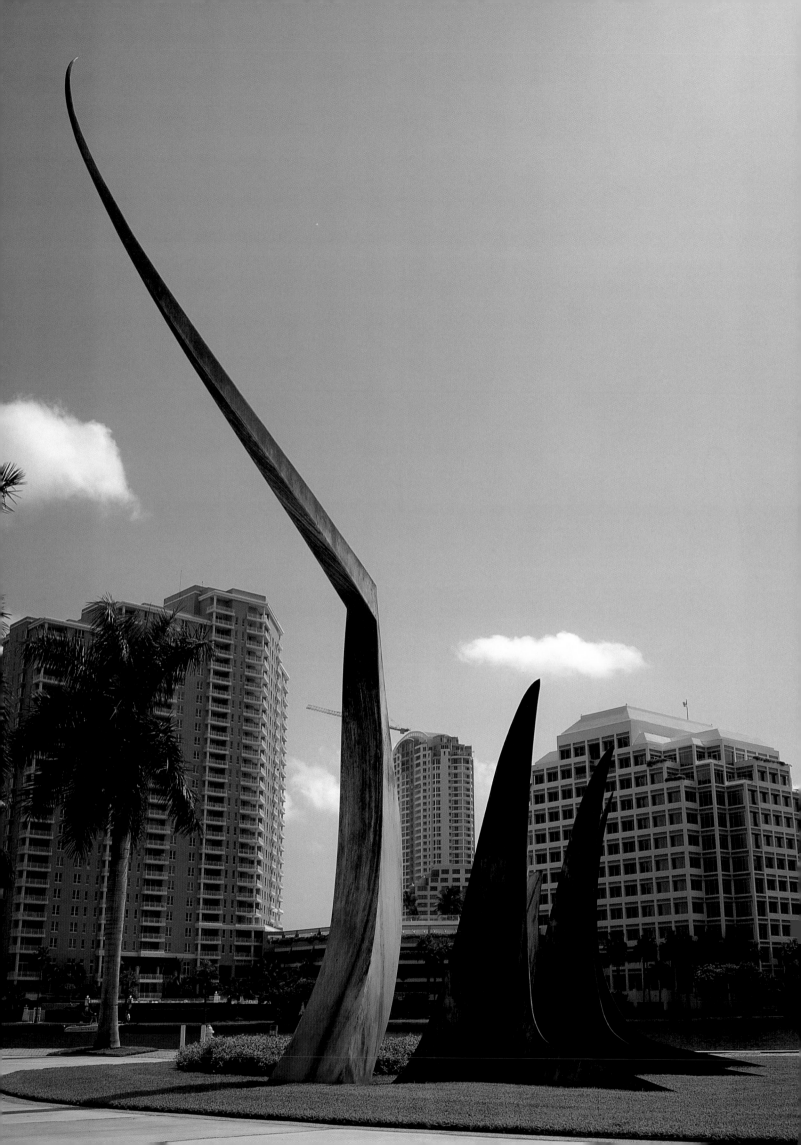

opposite:

Aquila, 1981
Bronze, 38' tall x 78' x 22'
NationsBank, Miami, Florida

right:

My Eagle, 1981
Graphite on paper, 18" x 12"
Ralph T. Cantin, Palm Beach, Florida

below:

Aquila, 1981
Bronze, 38" tall x 78" x 22"
The Newark Museum, Newark, New Jersey

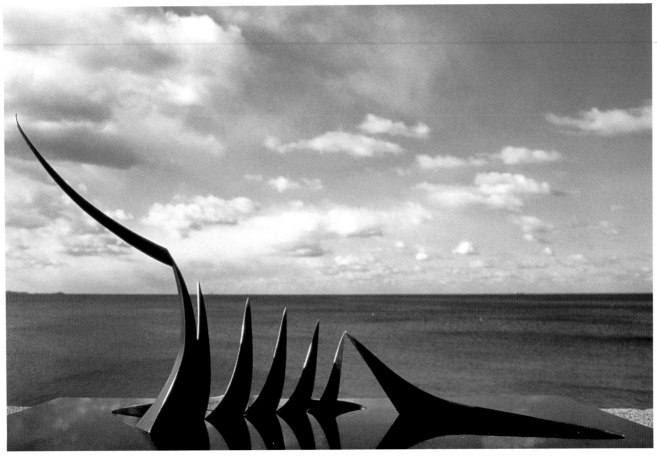

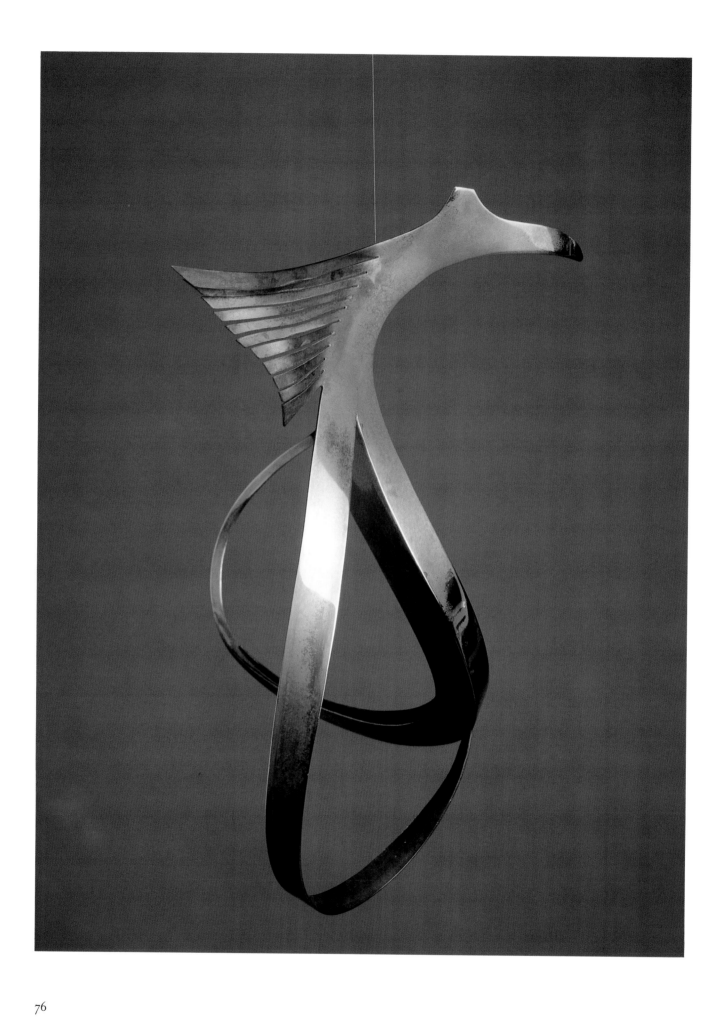

opposite:

Ariel, 1984
Bronze, 18" tall x 9" x 9"
Ruth Viny, Pepper Pike, Ohio

Ariel, 1984
Aircraft aluminum, 12' tall x 6' x 6'
Arvida JMB Headquarters, Boca Raton, Florida

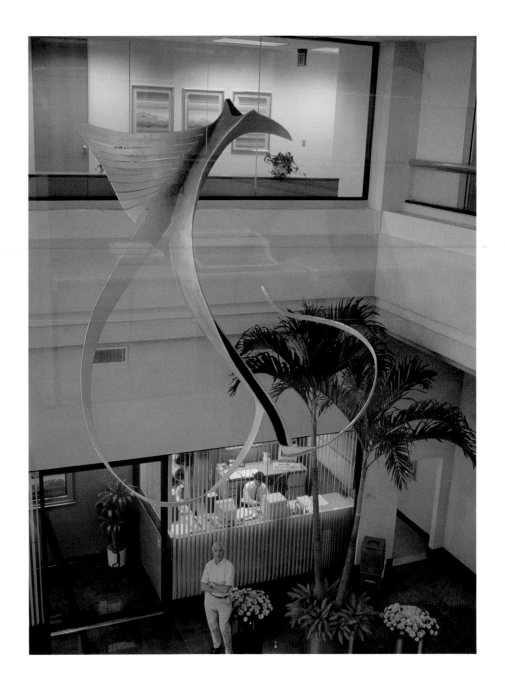

opposite:

Lupus, 1985
Bronze, 40" tall x 8" x 7"
Ron and Ellen Gerard, Kennebunk, Maine

Cherubim, 1985
Bronze, each 16' across
Temple Emanu-El, Miami Beach, Florida

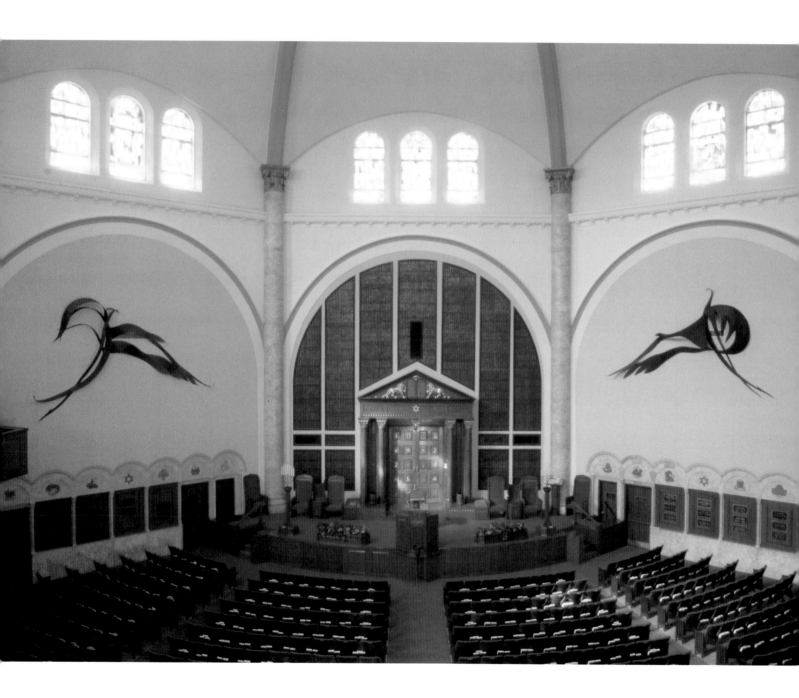

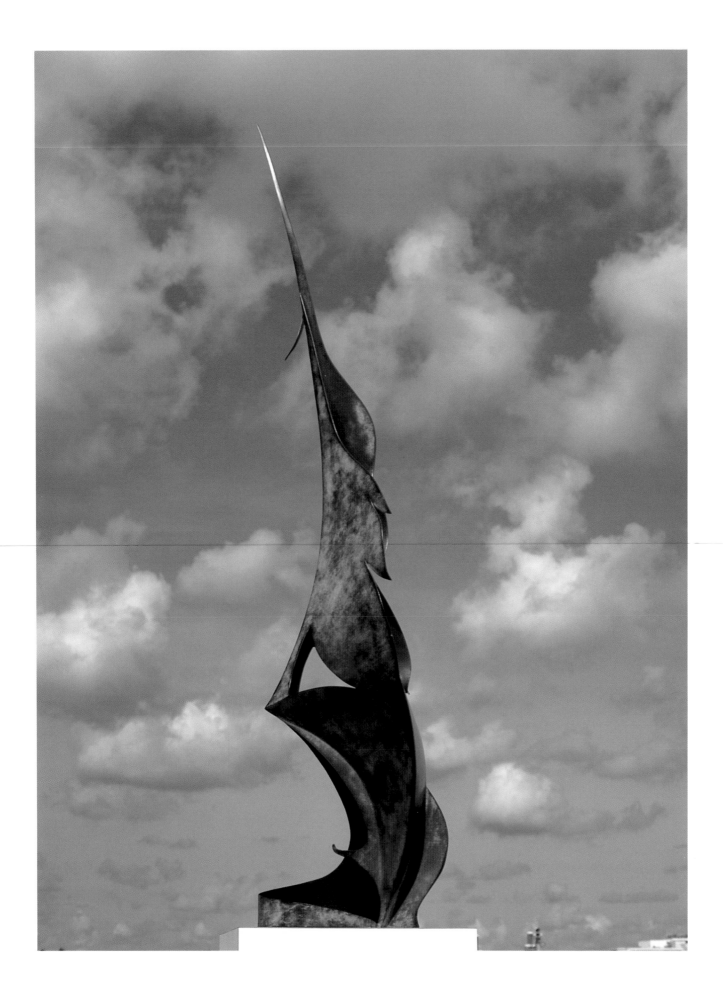

opposite:

Lupus, 1985
Cor-ten steel, 40' tall x 8' x 7'
Lotus Development Corp., Cambridge, Massachusetts

Three Gray Wolves, 1982
Chalk on paper, 22" x 30"
Museum of Fine Arts, Boston, Massachusetts

Heart of Wolf, 1982
Oil stick on paper, 13" x 15"
Sandy Green, New York, New York

October Wolf, 1982
Oil stick on paper, 23" x 19½"
Dolly Fiterman, Minneapolis, Minnesota

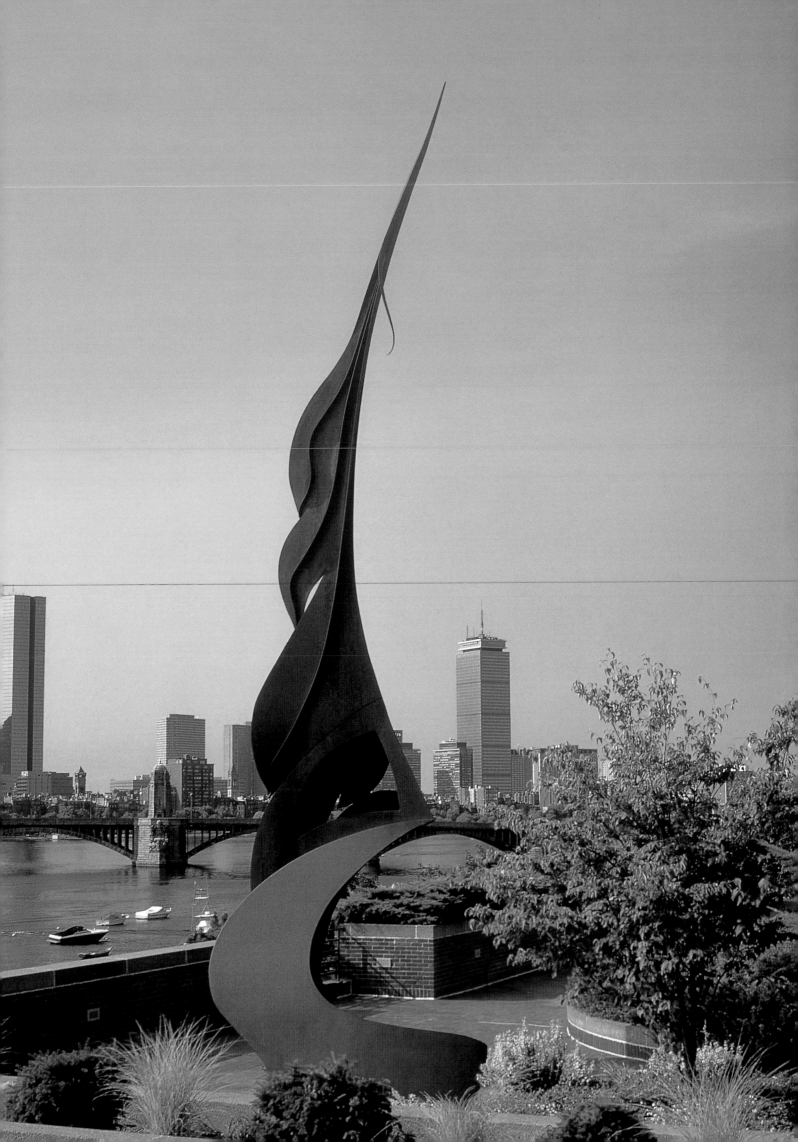

Cry, 1982
Graphite on paper, 14" x 18"
Lois Pope, Manalapan, Florida

opposite:

Lupus, 1985
Bronze, 14' 8" tall
Hubert and Bitti Steingass, Manalapan, Florida

Lupus (detail), 1985
Cor-ten steel, 40' tall x 8' x 7'
Lotus Development Corp., Cambridge, Massachusetts

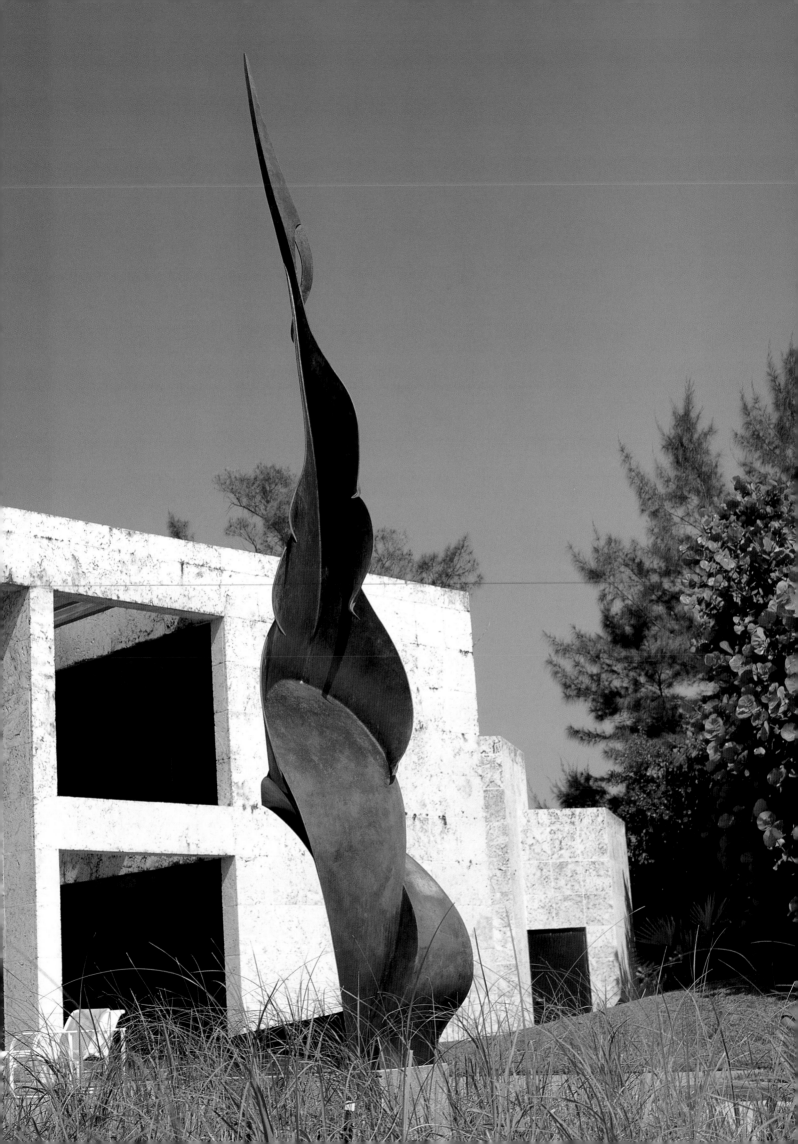

Dian, 1987
Stainless steel, 43" tall x 14½" x 13"
Werner and Elizabeth Schumann, Cabin John, Maryland

opposite:

Dian, 1987
Stainless steel, 26'6" tall x 7'3" x 6'6"
Admiralty Properties Ltd., Palm Beach Gardens, Florida

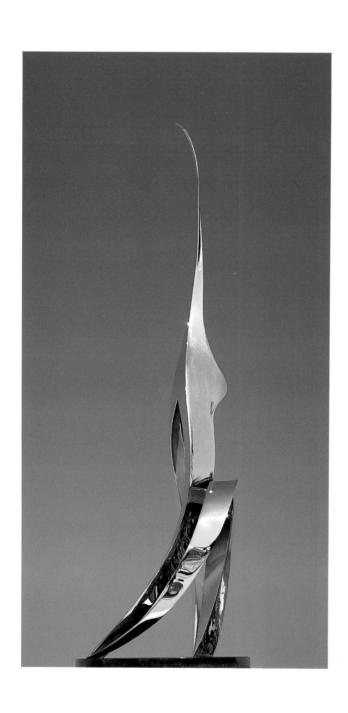

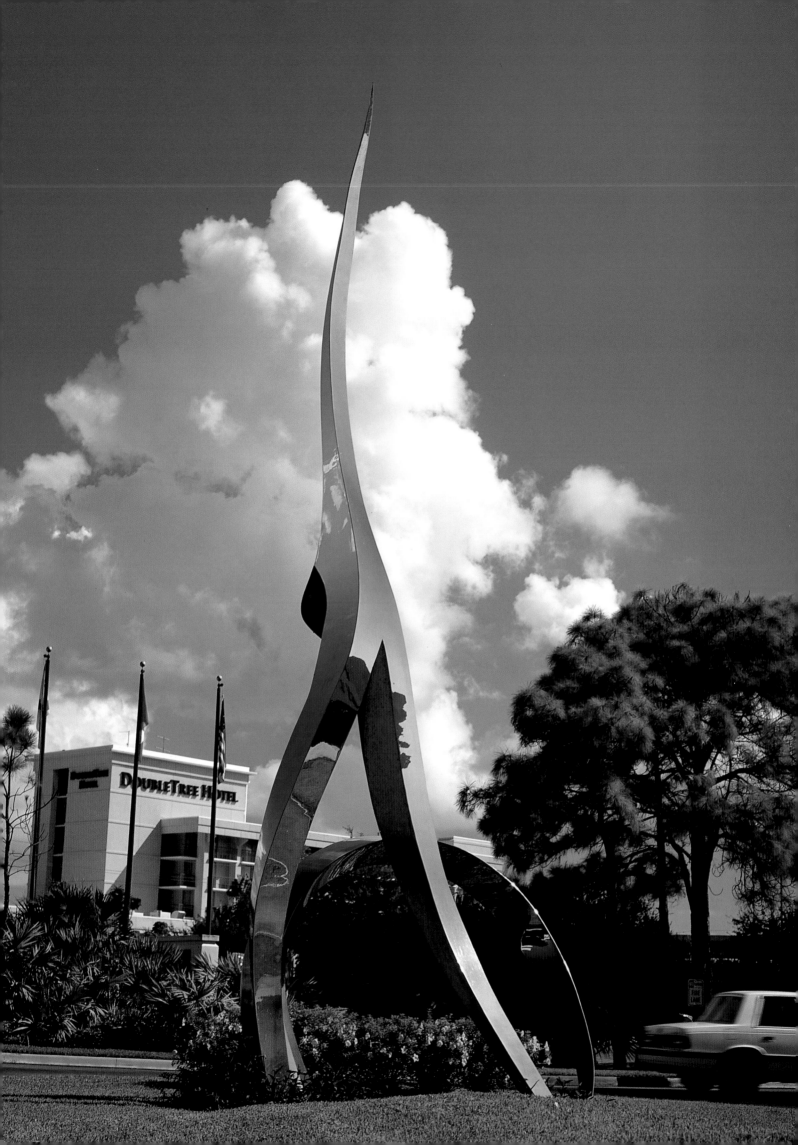

opposite:

Dance of the Cranes, 1988
Bronze, 10' tall
Leslie Claydon White and David Velselsky, Mill House,
Woodbury, Conneticut

Dian, 1987
Stainless steel, 10'9" tall x 3'8" x 3'3"
Leandro Rizzuto, Greenwich, Connecticut

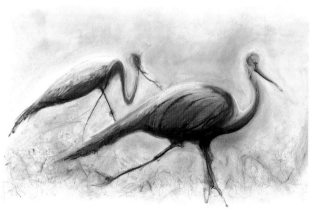

Dancer from the Dance, 1987
Ink on paper, 22" x 30"
Private collection, Palm Beach, Florida

top:

Wing, 1987
Ink on paper, 29" x 21"
Max and Cil Draime, Warren, Ohio

African Cranes, 1987
Oil stick on paper, 48" x 72"
Richard and Barbara Caturano, Gloucester, Massachusetts

opposite, and pages 90 and 91 (detail):

Dance of the Cranes, 1988
Bronze, 60' tall x 33' x 15'
Omaha Airport Authority

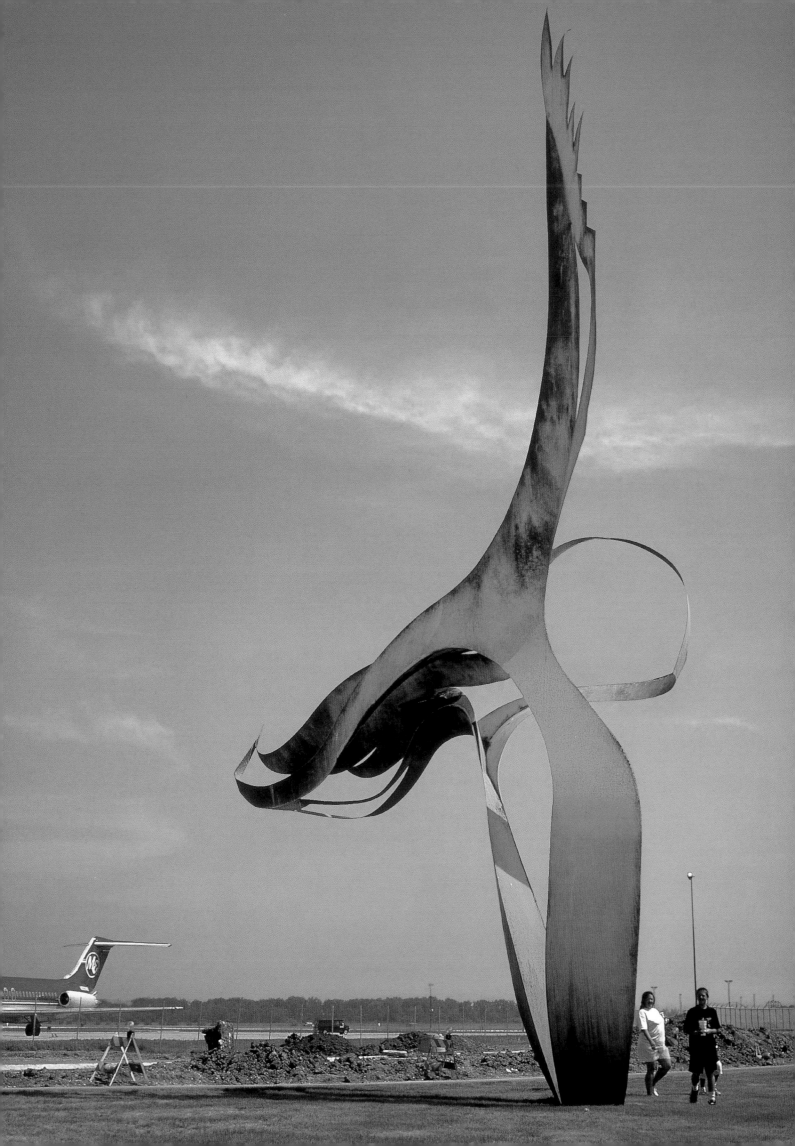

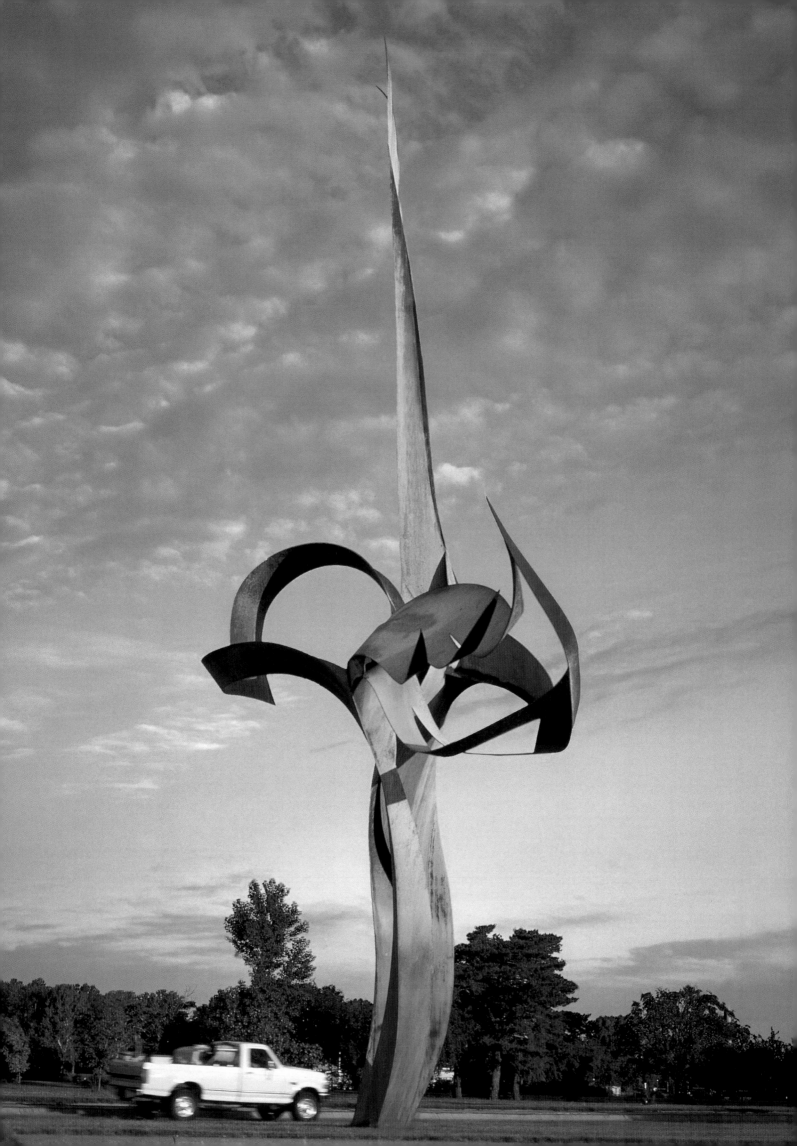

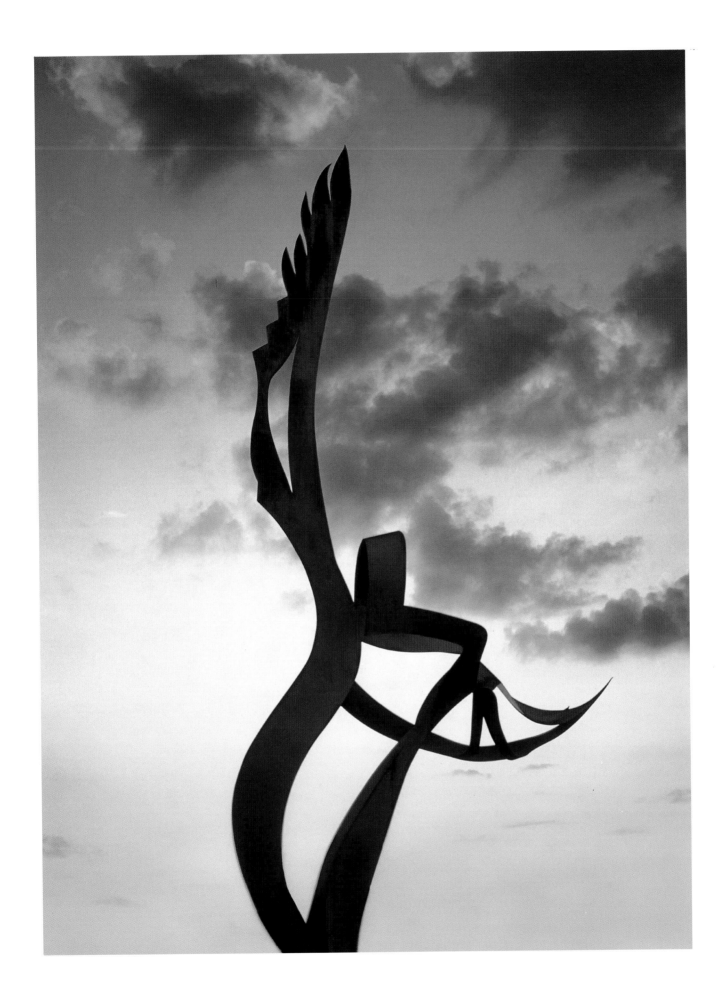

below:

The Moment, 1988
Inks on paper, 36" x 22"
Elly Jongeneel and CJ Van Schaffelaar, Baarn,
The Netherlands

right:

Spirit Ascending, 1988
Bronze, 39" tall
John Axelrod, Boston, Massachusetts

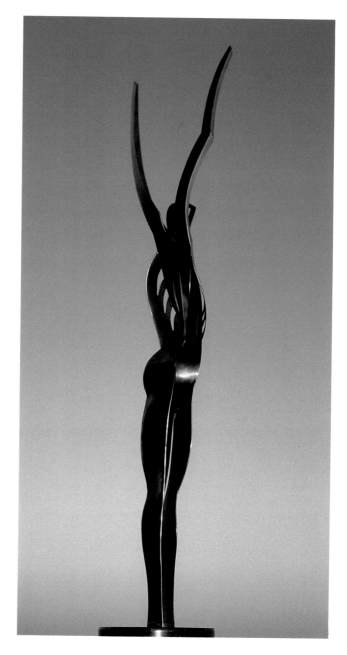

opposite:

Spirit Ascending, 1988
Bronze, 13' tall
Robert and Mary Montgomery, Palm Beach, Florida

page 94:

Spirit Ascending, 1988
Bronze, 26' tall
Max and Cil Draime, Warren, Ohio

page 95:

Spirit Ascending, 1988
Bronze, 39' tall
Palm Beach Opera, West Palm Beach, Florida

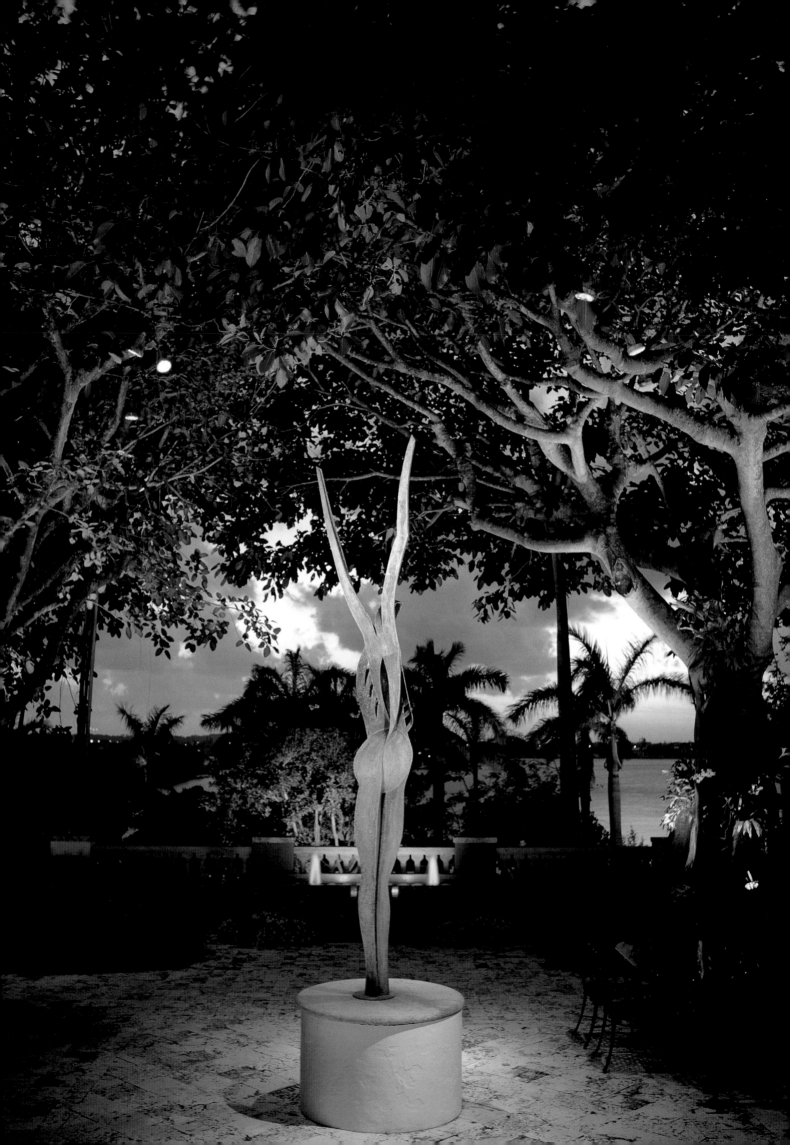

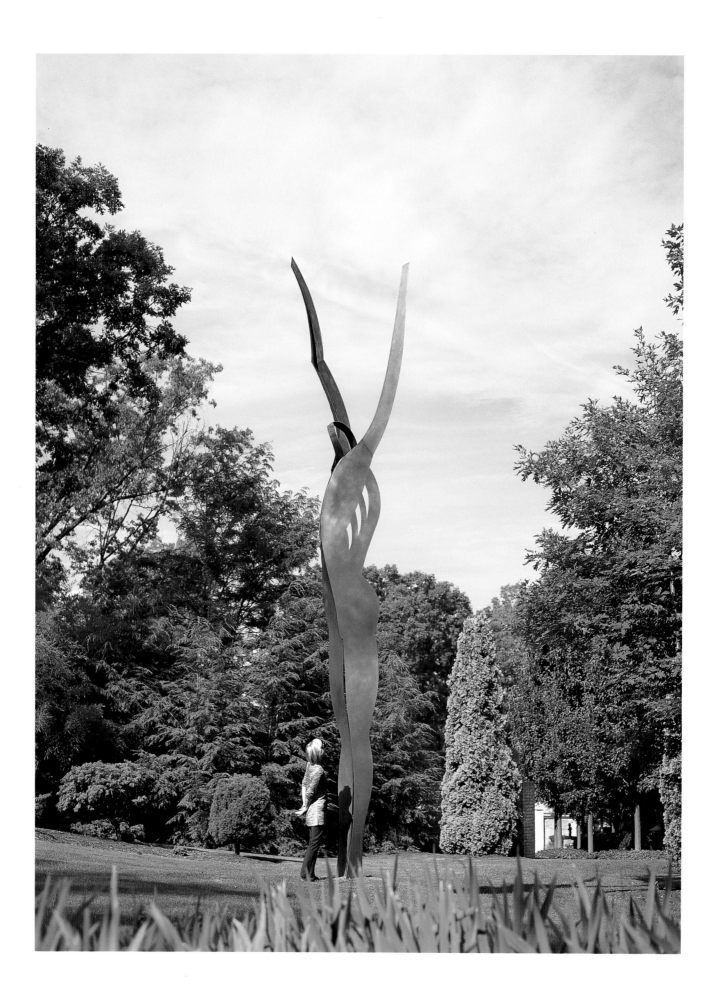

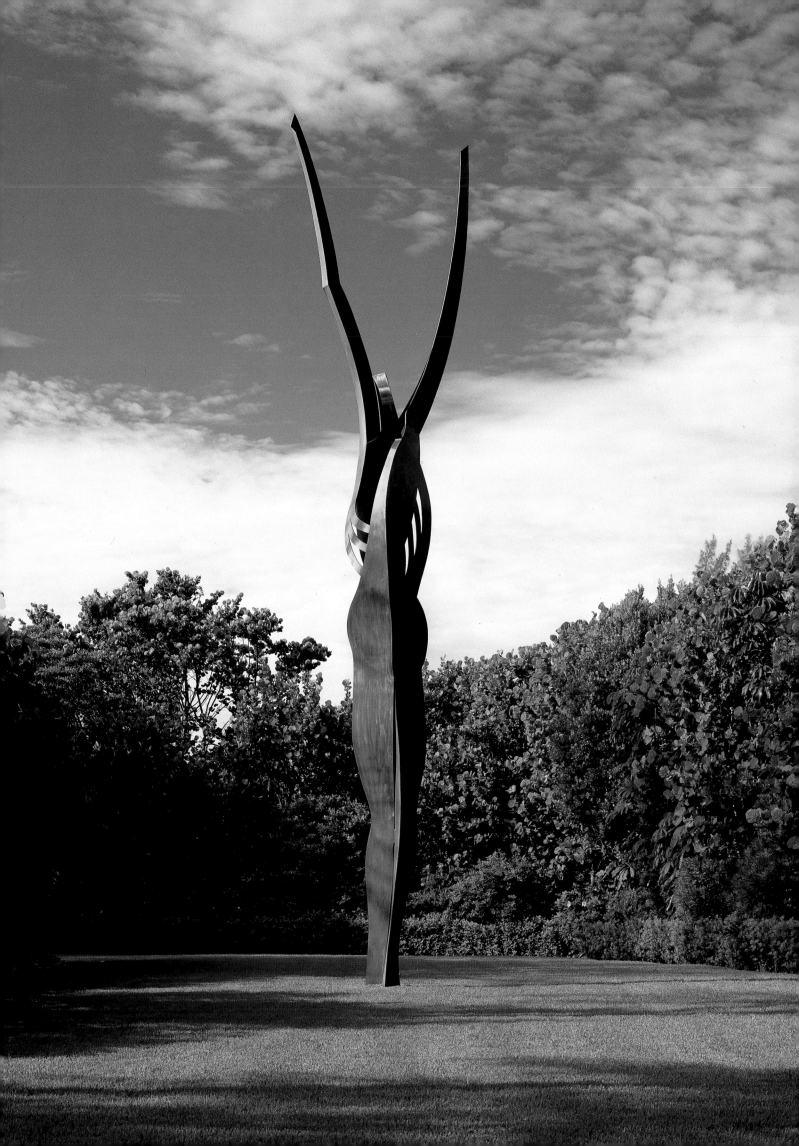

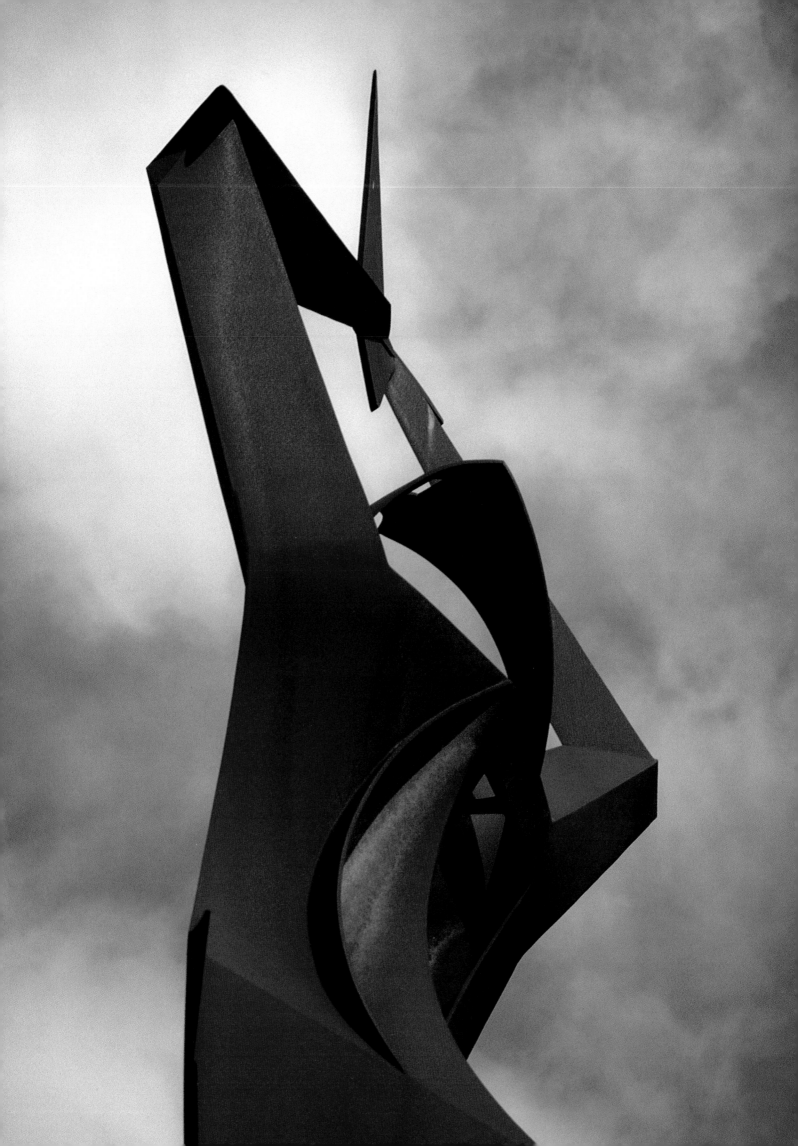

page 96:

Artorius, 1989
Silvered bronze, 41" tall
Rudy and Susan Schupp, North Palm Beach, Florida

page 97:

Artorius (detail), 1989
Cor-ten steel, 41' tall
Stockley Park, Heathrow, Glaxo Wellcome,
Uxbridge, England

opposite:

Artorius, 1989
Bronze, 13' 6" tall
Currier Museum of Art, Manchester, New Hampshire

Artorius, 1989
Bronze, 20' 6" tall
Steve and Becky Gang, Aurora, Ohio

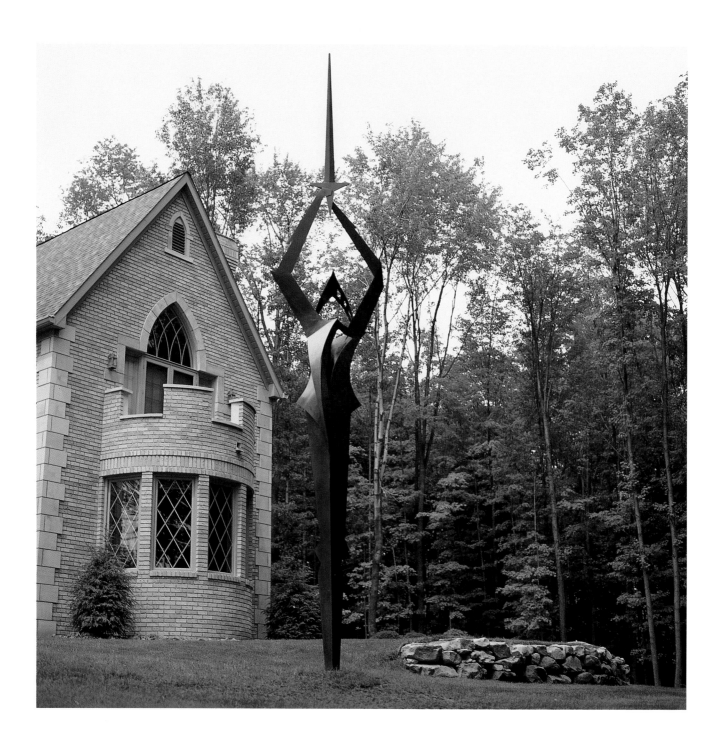

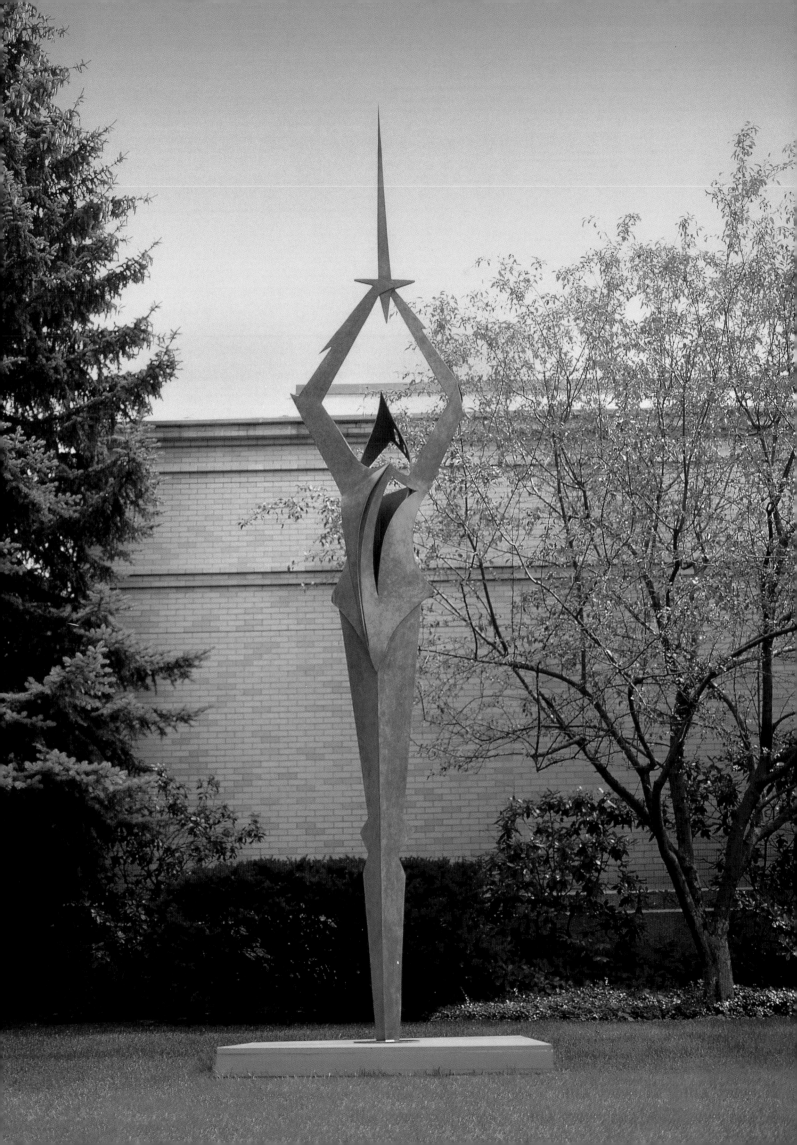

opposite:

Athleta, 1990
Bronze, 29' tall x 20' x 12'
University of Nebraska, Kearney

right:

Athleta
1990, Bronze, 58" tall x 40" x 24"
Fort Lauderdale Museum of Art, Florida

Billy, 1990
Chalk and conté, 60" x 30"
Robert and Mary Montgomery, Palm Beach, Florida

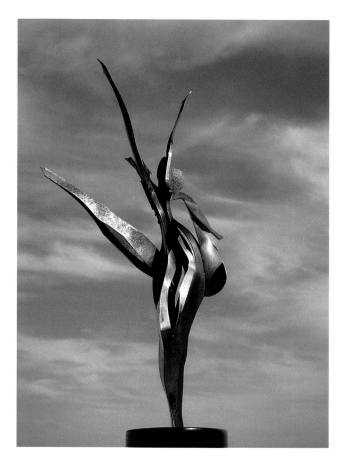

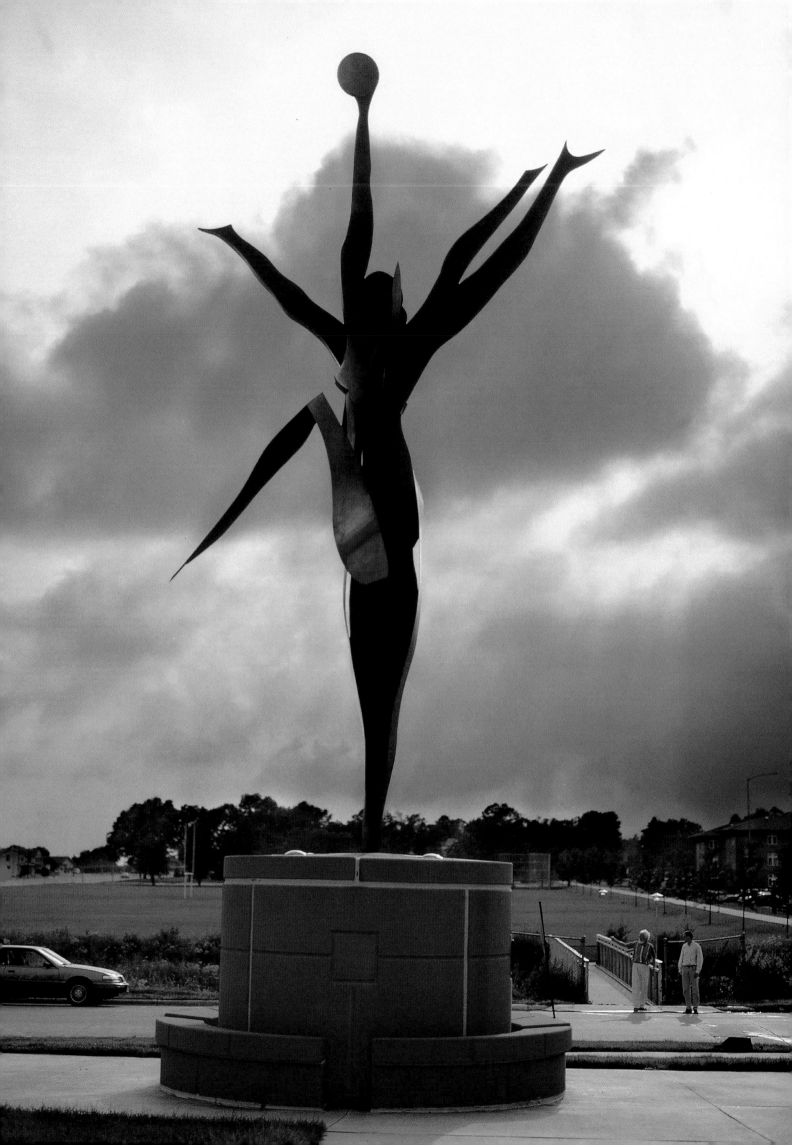

opposite:

Eurus, 1990
Bronze, 22'6" tall
Charles R. Wood, Lake George, New York

Eurus, 1990
Bronze, 45" tall
Dorothy Lappin, New York, New York

Grace, 1992
Ink on paper, 55" x 42"
Charles R. Wood, Lake George, New York

opposite:

Grace, 1990
Stainless steel, 11' 3" tall
Southwest Florida International Airport, Fort Myers, Florida

Grace, 1990
Bronze, 5'8" tall
Bruce and Jean Johnson, West St. Paul, Minnesota

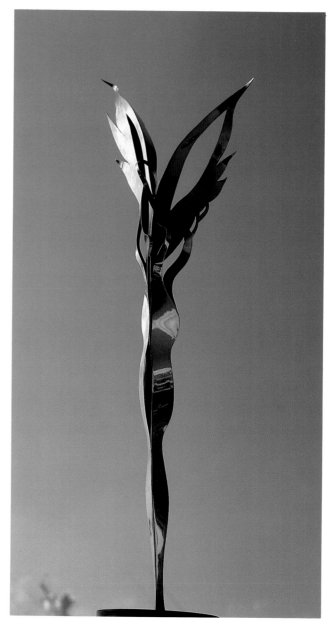

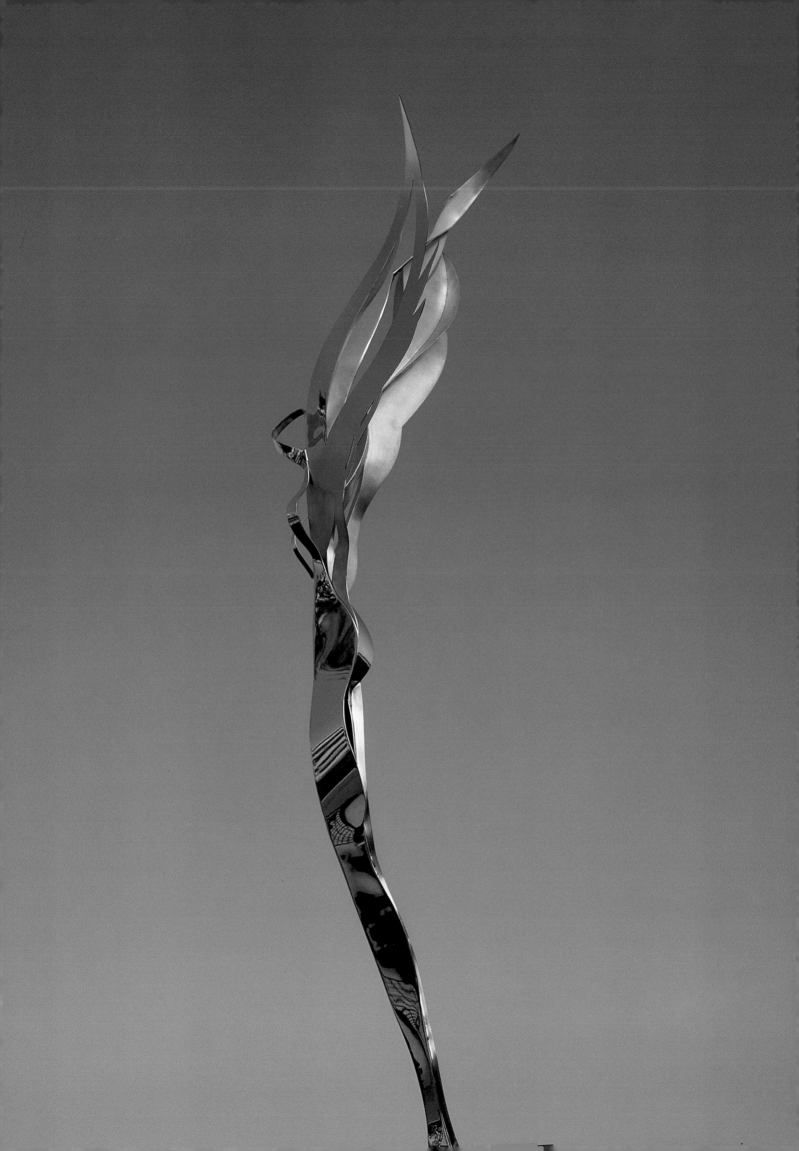

opposite:

Bravo, 1992
Bronze, 28' tall x 28' x 12'
University of Richmond, Richmond, Virginia

Bravo, 1992
Bronze, 8' tall x 8' x 3'6"
Marvin and Sandra Rubin, Delray Beach, Florida

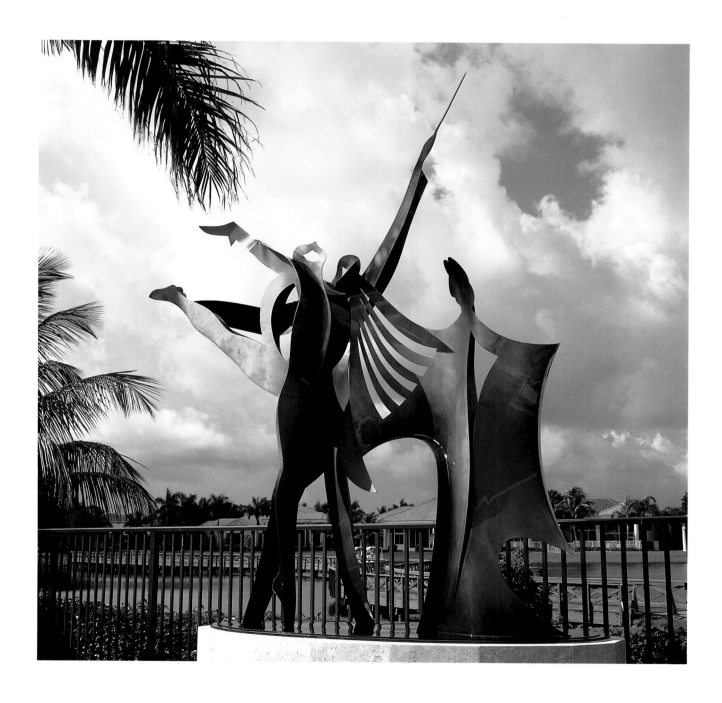

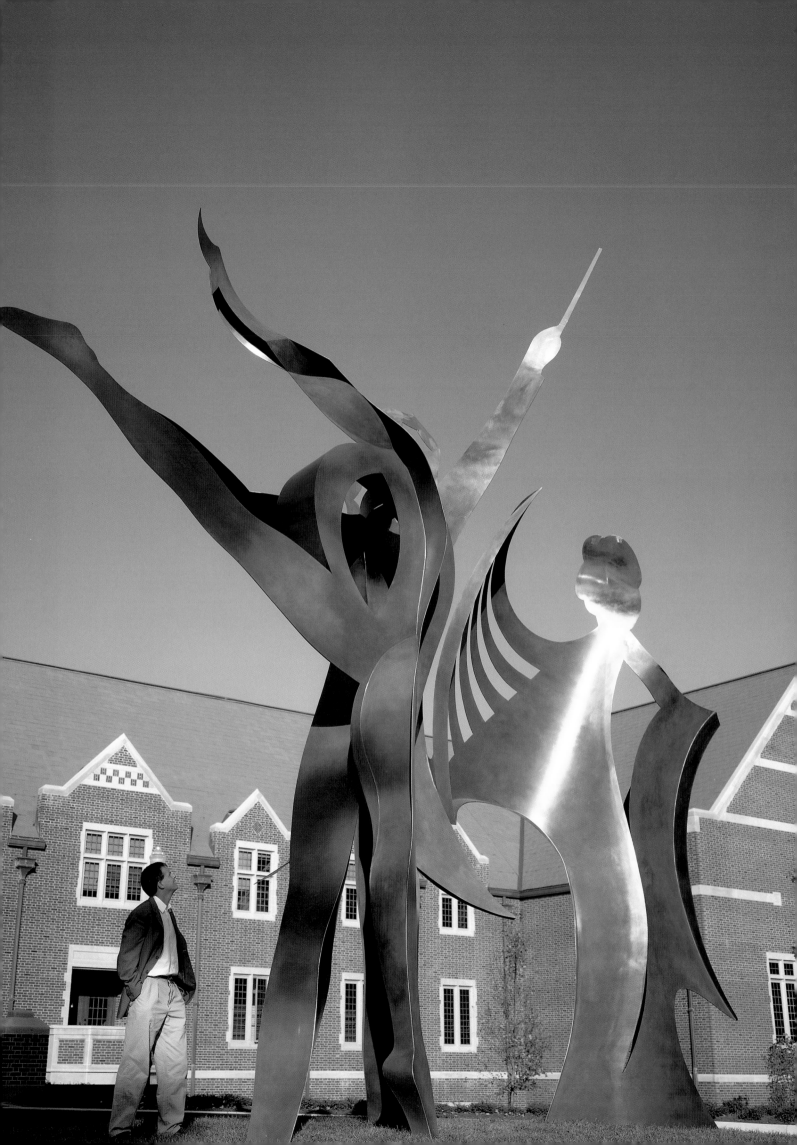

opposite and below (interior detail):

Pyre, 1992
Bronze, 68" tall
Private collection, Fisher Island, Florida

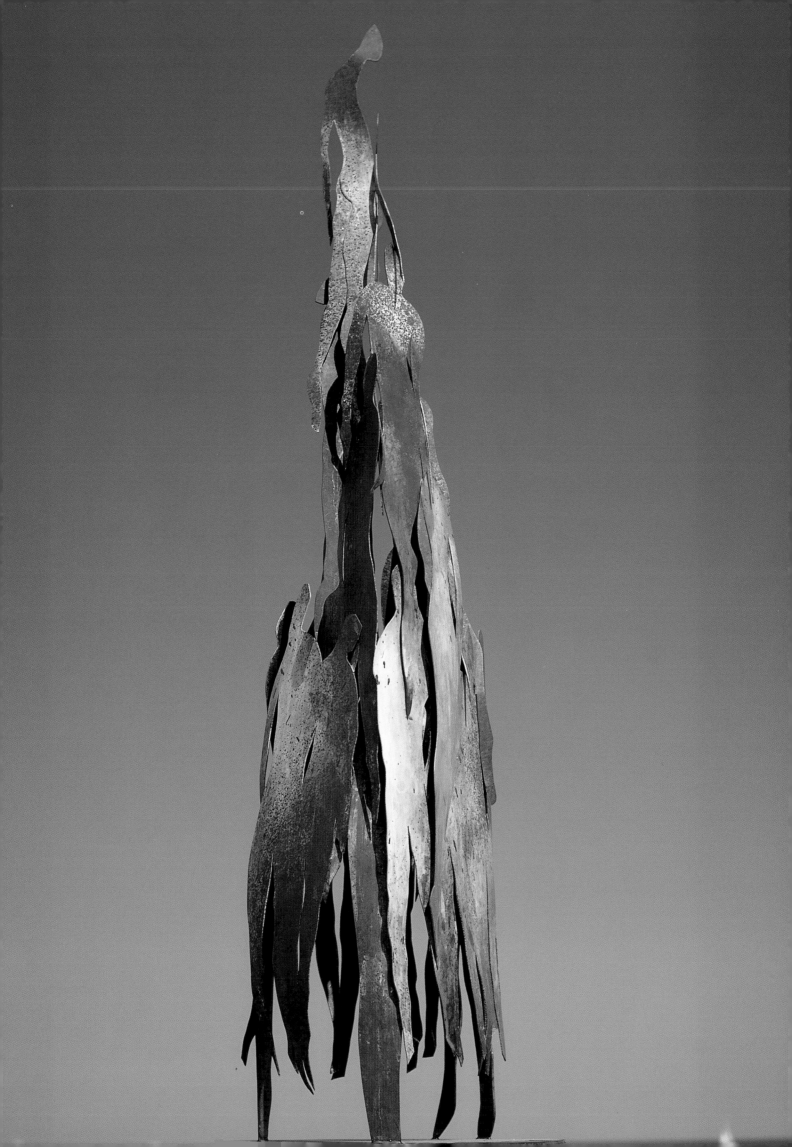

opposite:

Sarah, 1993
Bronze, 9' tall x 5' x 2'6"
Michael and Michelle Ritter, Boulder, Colorado

Abaris, 1992
Bronze, 36" tall x 12" x 12"
Vitale, Caturano & Co., P.C., Boston, Massachusetts

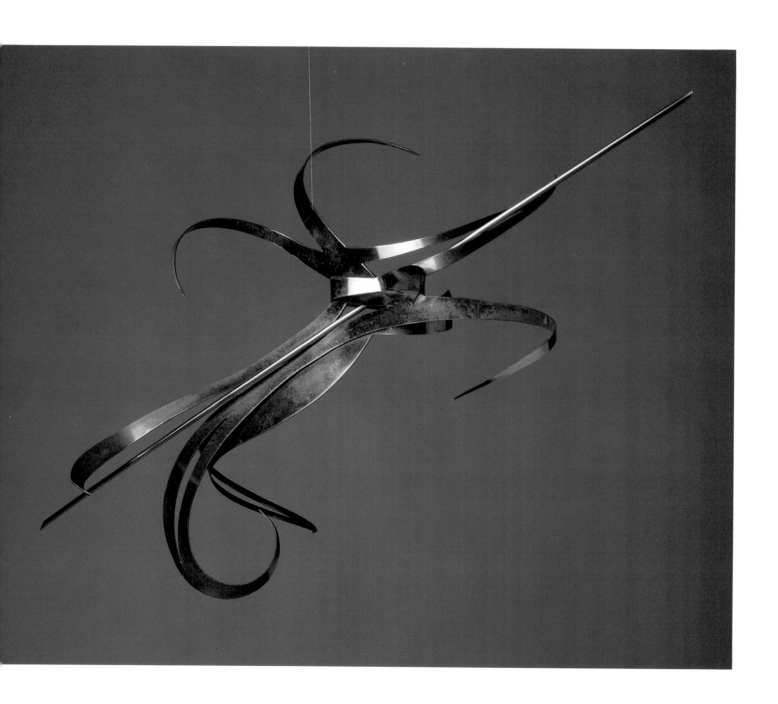

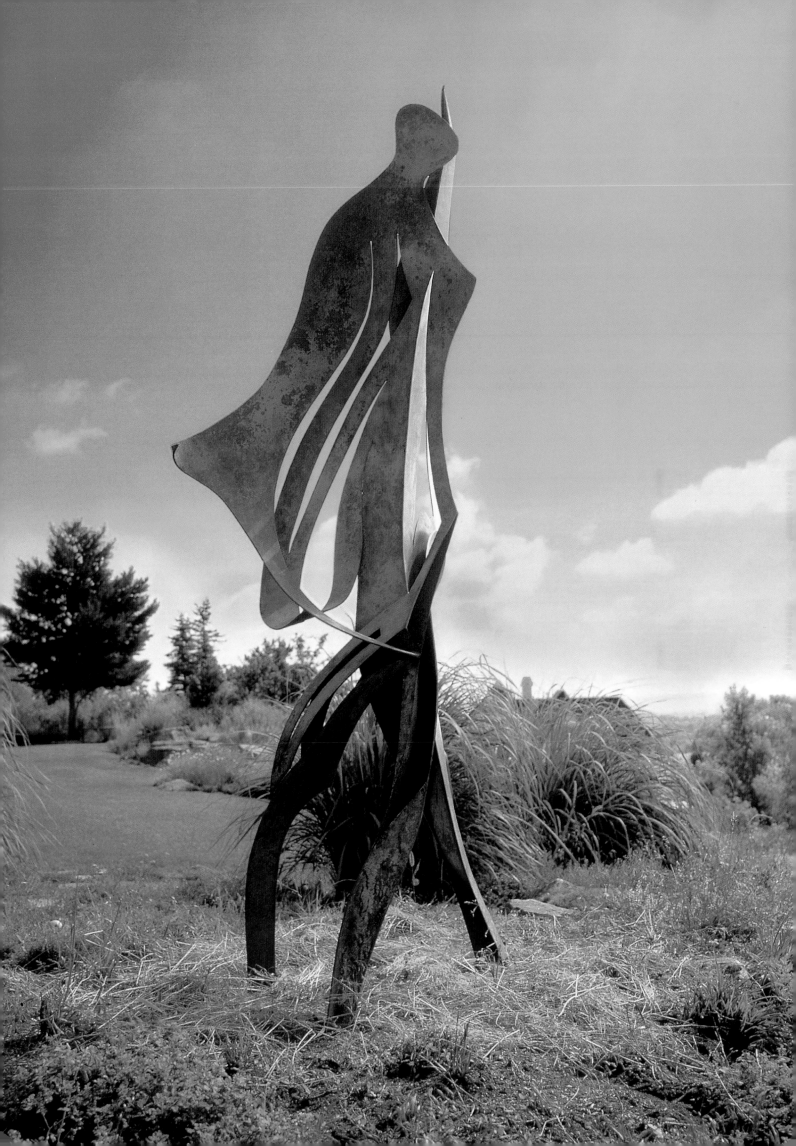

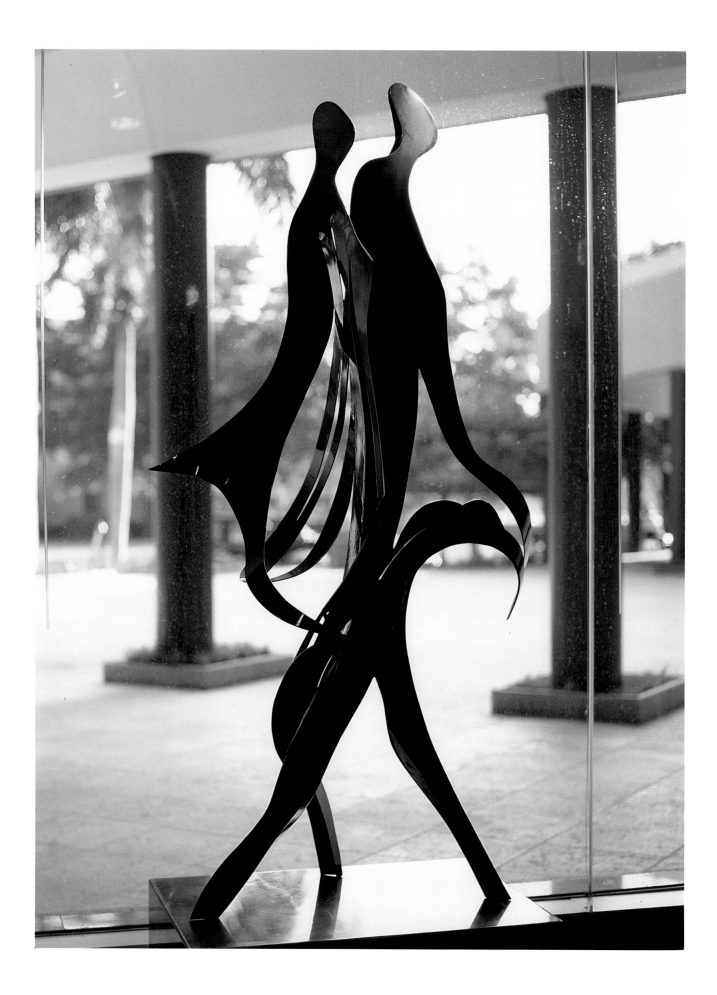

opposite:

Sarah, 1993
Bronze, 6' tall x 3' 6" x 1' 8"
Republic Security Bank, West Palm Beach, Florida

Sarah, 1993
Bronze, 6' tall x 3'6" x 1'8"
Joseph Kerzner, Toronto, Canada

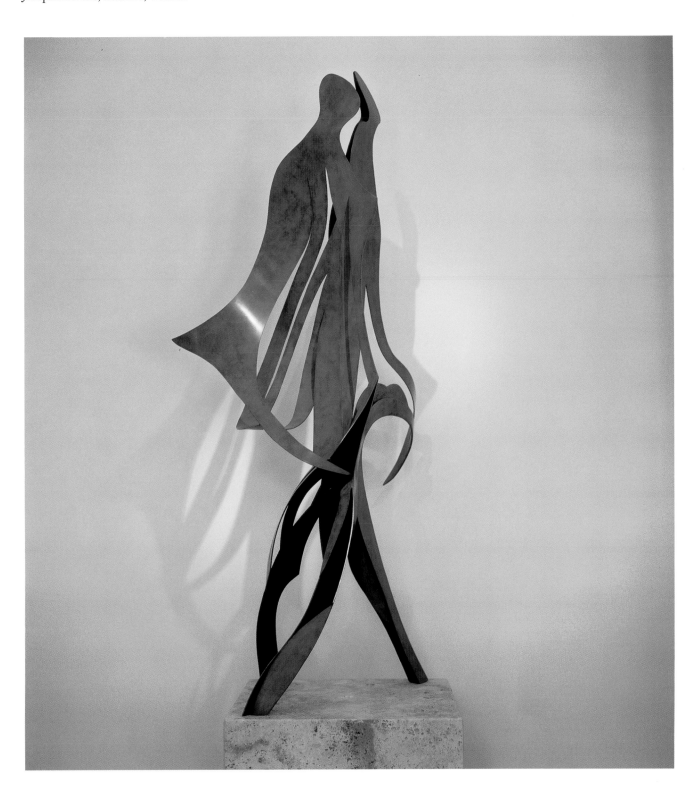

Ceres, 1994
Bronze, 36" x 12" x 12"
Peter Czajkowski and Juliet Chayat, St. Louis, Missouri

opposite:

Ceres, 1994
Bronze, 12' x 3' x 3'
Max and Cil Draime, Palm Beach, Florida

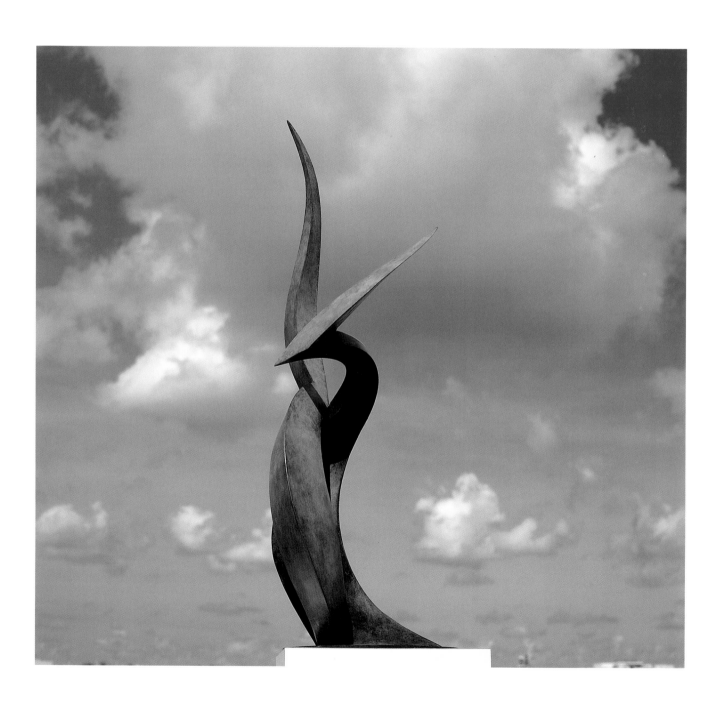

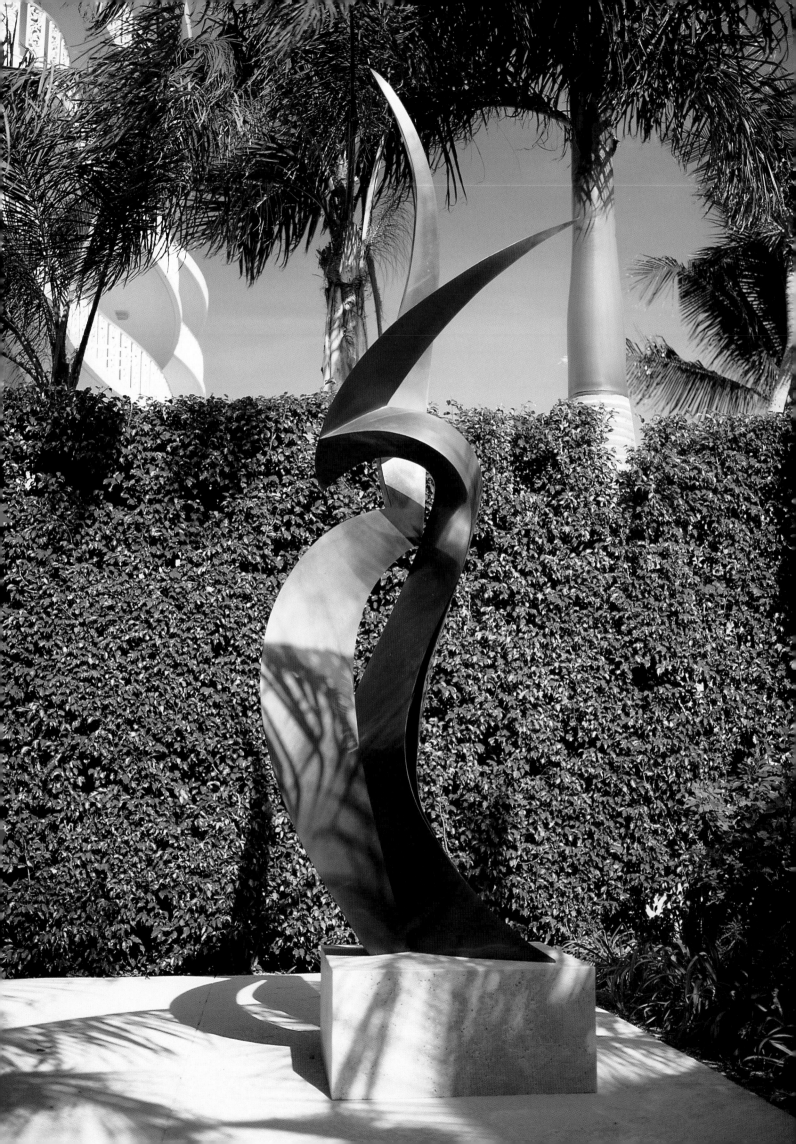

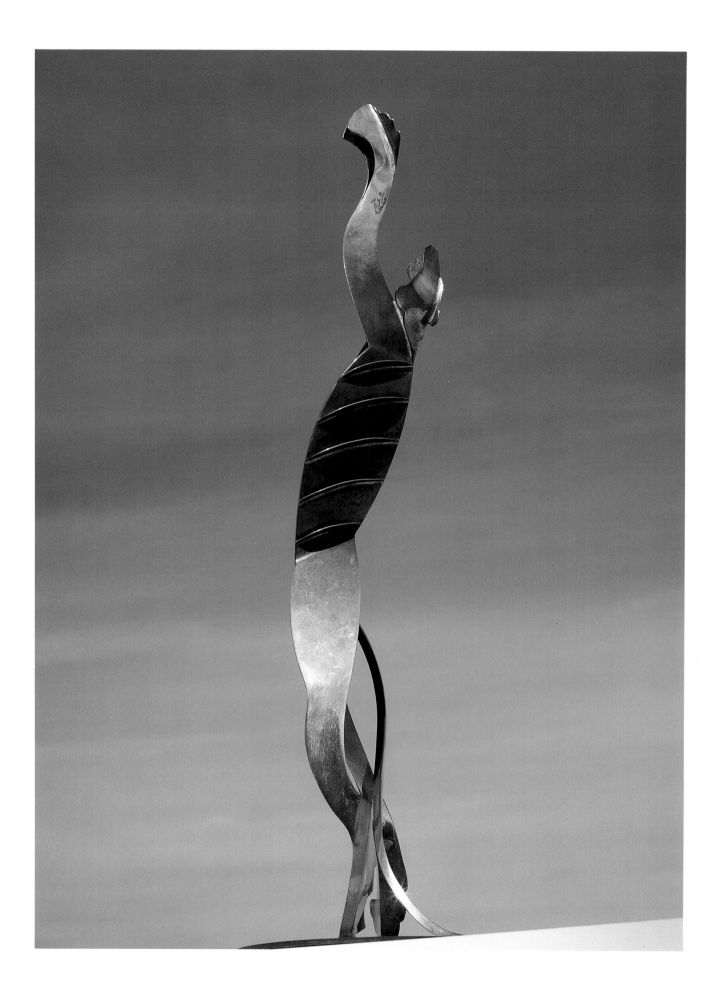

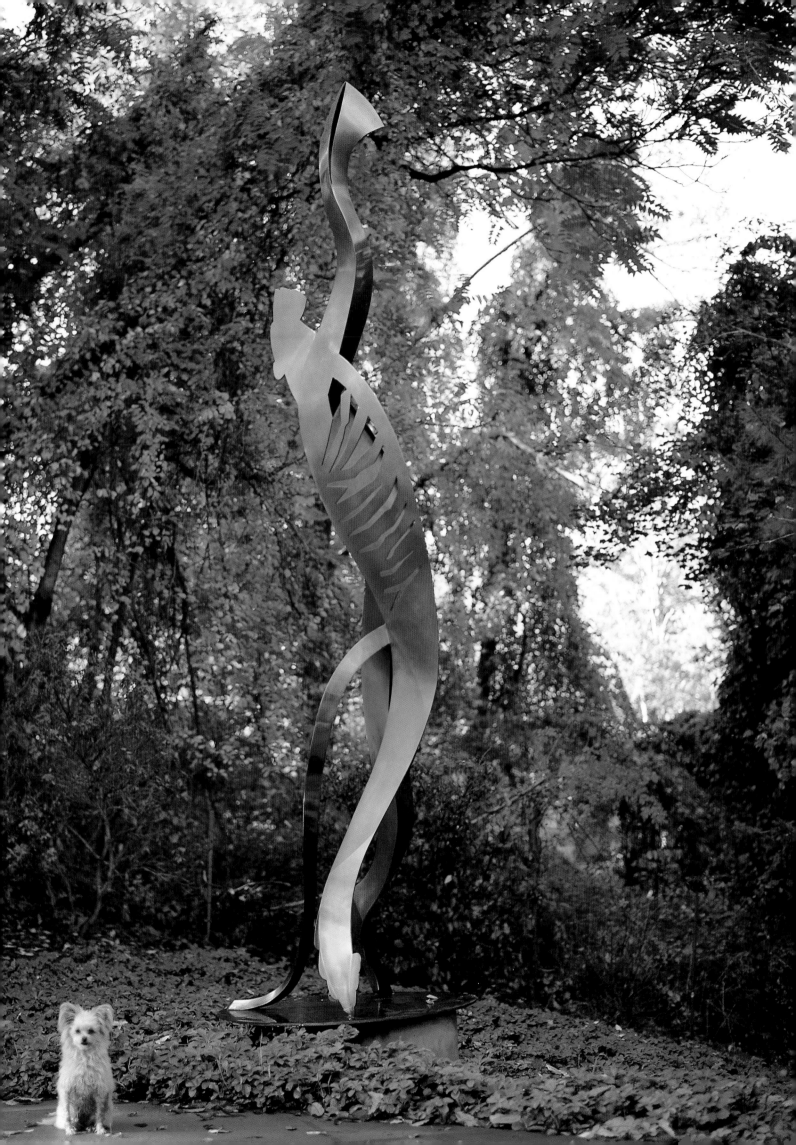

page 116:

Tigris, 1995
Bronze, 72" tall
Dr. C. P. and Susan Chambers, Manalapan, Florida

page 117:

Tigris, 1995
Bronze, 12' tall
Glenn Satty, Minneapolis, Minnesota

below:

Self-Portrait as a Tiger, 1989
Oil stick on paper, 20" x 20"
Fred and Kit Bigony, Jupiter, Florida

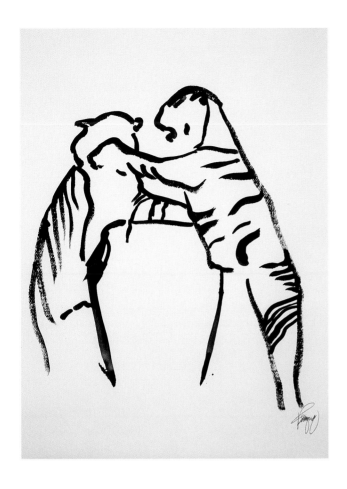

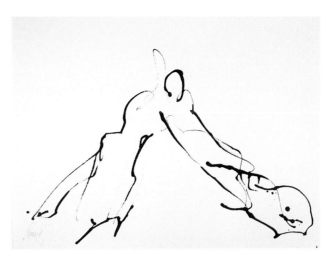

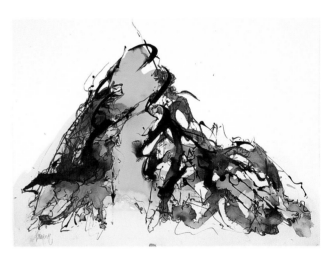

Dancing Tiger, 1995
Ink on paper, 30" x 22"
Walter and Gail Klevay, Fort Lauderdale, Florida

right, top to bottom:

Lovers, 1996
Inks on paper, 32" x 42"
Allen Memorial Art Museum, Oberlin, Ohio

Disce, 1996
Inks on paper, 32" x 39"
Max and Cil Draime, Warren, Ohio

Study for *Fatherhood (Journeys),* 1994
Inks on paper, 22" x 29"
Joseph DiGangi, Arlington, Virginia

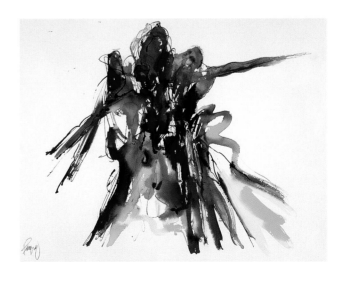

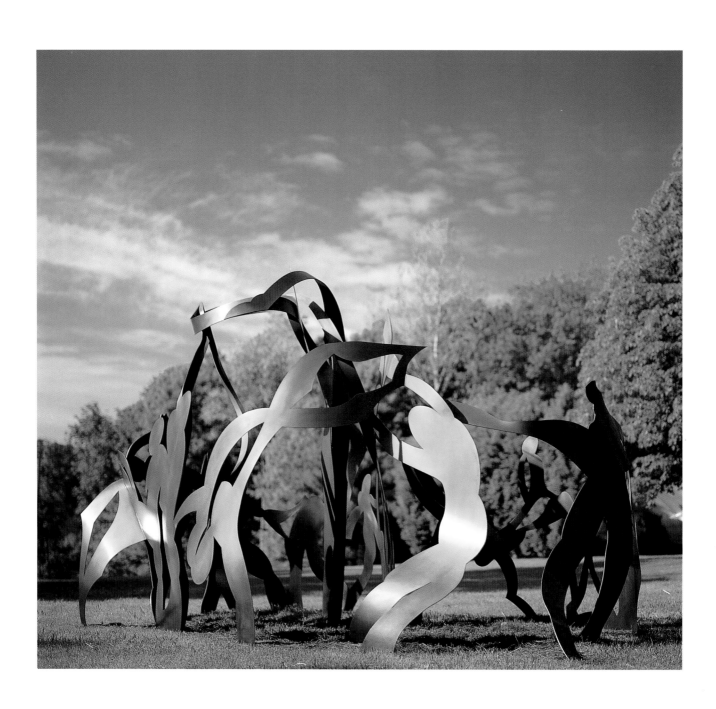

Chronology

1948

Born May 29 in Chelsea, Massachusetts, to Peter John Raimondi and Erma Oliver Raimondi, the first of four sons.

1955

Begins making scale-model airplanes, cars, and trains.

1958

Moves to Winthrop, Massachusetts. Starts drawing and painting. Begins collecting coins and working on model cars.

1966

Art and theater student in high school, paints cover of the yearbook. Attends Vesper George School of Art in Boston, Massachusetts.

1967

Works as a commercial artist for University Press, Winchester, Massachusetts.

1968

Summer, extensively tours the United States and is inspired by Niagara Falls and the Grand Canyon.

1969

January, moves to Rockport, Massachusetts, to study and work as an independent artist. September, attends the Portland School of Fine and Applied Arts in Portland, Maine (now called Maine College of Art), where instructor Norman Therrien provides first exposure to Brancusi, Moore, Calder, and David Smith. Studies photography with Nick Dean.

Peter and Erma Raimondi with John in 1951

Raimondi with 1939 Ford, Autorama, Boston, Massachusetts, 1966

Raimondi as seascape painter, Winthrop High School newsletter, 1966

Student exhibition at Massachusetts College of Art, 1969

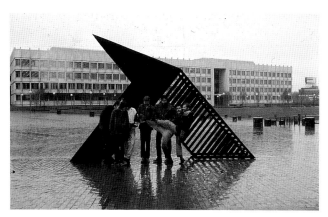

Installation of *Cage* at Boston City Hall Plaza, 1971

1970

Attends Massachusetts College of Art in Boston. Studies with and assistant to instructor George Greenamyer. Begins creating monumental sculptures.

1971

Begins an 8-year series of geometric sculptures, *Cages and Castles.*

April, creates and fabricates *Cage* for an exhibition at Boston City Hall Plaza.

June, works as artist-in-residence at Haystack-Hinckley School in Hinckley, Maine. Creates and fabricates *Christopher.*

Lectures at Boston Visual Artists Union and Hobart and William Smith Colleges, Geneva, New York.

1972

Creates and fabricates garden-scale *David,* 7 feet tall. Exhibits with Boston Visual Artists Union at Boston City Hall Gallery. Creates and fabricates *Nod,* 20 feet tall, which is exhibited at the Boston Center for the Arts and acquired by Bridgewater State College, Bridgewater, Massachusetts. Lectures at Haystack Mountain School of Crafts, Deer Island, Maine; New England Sculptor's Association, Boston, Massachusetts; and Philips Exeter Academy, Exeter, New Hampshire.

1973

April, is awarded a commission for a sculpture in the Massachusetts Art Summer '73 Project. Creates and fabricates *Stephen's Summer* for a highway rest area on I-91 at the Vermont border.

May, receives BFA degree from Massachusetts College of Art.

September, is awarded the first artist-in-residence grant at a vocational school from the National Endowment for the Arts (NEA) to develop pilot Artist-in-Schools project at invitation of Massachusetts Council on Arts. Begins a yearlong residency at Quincy Vocational Technical School in Quincy, Massachusetts.

November, creates and fabricates *JAT,* 30 feet tall, a private commission for a farm overlooking Seneca Lake in Geneva, New York.

Lectures at Cedar Rapids Arts Center, Cedar Rapids, Iowa; Leverett Craftsmen and Artists, Inc., Leverett Center, Massachusetts; Museum of Fine Arts, Boston, and National Endowment for the Arts, Washington, D.C.

1974

Fabricates monumental *David,* 20 feet tall, and exhibits it at Southeastern Massachusetts University, Dartmouth, Massachusetts.

Summer, creates and fabricates *Michael,* 18 feet tall, as an artist-in-residence at Boston City Hall Plaza for Institute of Contemporary Art Works in Progress. Exhibits sculptures and drawings at the Brockton Art Center, Brockton, Massachusetts, his first museum exhibition.

September, is awarded a second NEA artist-in-residence grant for the Portland Regional Vocational Technical Center and moves to Portland, Maine.

Begins relationship with James "Chip" Morel.

Lectures at Bowdoin College, Brunswick, Maine; Institute of Contemporary Art, Boston; New England State Council on Arts and Humanities, Boston; Notre Dame University, South Bend, Indiana; Portland Museum of Art, Portland, Maine; and University of Maine, Orono, Maine.

Serves on Special Arts Projects Advisory Committee, Massachusetts Council on the Arts and Humanities, Office of Educational Affairs.

1975

January, *Michael* is purchased by Canal National Bank and donated to the City of Portland. Guggenheim Productions is commissioned by the NEA to produce a documentary film on Raimondi's residency at the Portland School and the creation of *Michael.*

April, with his proposal for *Erma's Desire,* is awarded one of eight commissions in the Nebraska I-80 Bicentennial Sculpture Project, a national competition.

Lectures at The Brooks School, Andover, Massachusetts; Colby College, Waterville, Maine; Howard University, Washington, D.C.; Lousiana State University, Baton Rouge, Louisiana; State Art Advisory Board, Portland, Maine; University of Massachusetts, Amherst.

1976

January, exhibits at Sunne Savage Gallery, Boston, Massachusetts, his first one-person exhibition.

March, becomes a certified welder and lives in Nebraska for on-site fabrication of *Erma's Desire,* 26 feet tall.

Raimondi and his mother, Erma, Holiday Inn, Grand Island, Nebraska, 1976

Installation of *Erma's Desire,* Raimondi with James "Chip" Morel, 1976

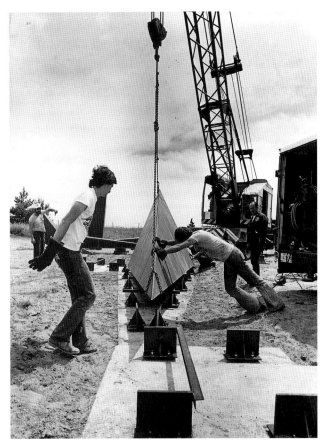

James "Chip" Morel (left) and Raimondi (right) installing *Erma's Desire,* Grand Island, Nebraska, 1976

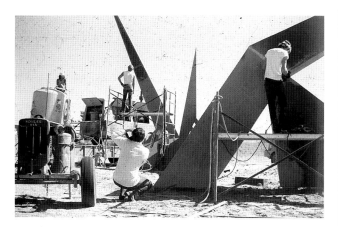

Installation of *Erma's Desire,* Grand Island, Nebraska, 1976

Raimondi as artist-in-residence, San Angelo Independent School District, 1979

Rear deck with *JAT* model, Bennington Street studio, East Boston, Massachusetts, 1980

Summer, Nebraska Educational Television (PBS) produces a one-hour documentary film, *The Five-Hundred Mile Sculpture Garden,* which includes a twenty-eight-minute segment on *Erma's Desire.*

Returns to Maine.

Lectures at Baxter School for the Deaf, Mackworth Island, Maine; Cumberland County Jail, Portland, Maine; Sheldon Memorial Art Museum, Lincoln, Nebraska.

1977

March, receives a private commission in Miami Beach, Florida, to create and fabricate *Lawrence,* 7 feet tall by 60 by 14 feet, on the Venetian Islands.

November, is awarded a commission for *Peter John,* 36 feet tall by 44 by 18 feet, through a national competition by Blue Cross/Blue Shield Headquarters, Milwaukee, Wisconsin.

1978

Moves back to East Boston.

Spring, is commissioned by developers Spaulding and Sly Corp. to fabricate *Evelyn,* 7 feet tall by 14 by 7 feet, for an IBM corporate building in Burlington, Massachusetts.

Visits Palm Beach, Florida, for the first time.

1979

February, is invited by the Texas Commission on Arts to be artist-in-residence at San Angelo Independent School District. Creates and fabricates *Ran,* 28 feet tall by 42 by 16 feet, for the Civic League Rose Garden in San Angelo. First visit to the Kimbell Art Museum in Fort Worth and inspired by natural forms, light, and spiritual quality of architecture by Louis Kahn.

October, begins drawings based on nature and the environment.

Ends relationship with James "Chip" Morel.

1980

January, creates and fabricates *Zephyrus,* 11 feet tall by 22 by 9 feet, a private commission on Nantucket Island, Massachusetts. The organic, flowing forms solidify the *Endangered Species* series.

Autumn, creates and fabricates *Equuleus,* 12 feet tall by 25 by 8 feet, for a private collector in Palm Beach, Florida.

1981

Begins relationship with Ralph T. Cantin.

Creates *Aquila*, a sculpture inspired by the eagle.

Becomes inspired by jazz music, particularly John Coltrane, Sarah Vaughan, and Chet Baker.

1982

September, exhibits in the *5th Anniversary Show at the C.Grimaldis Gallery* in Baltimore, Maryland, along with Willem and Elaine de Kooning and Grace Hartigan. Begins a close friendship with Hartigan.

October, is awarded 3-month fellowship at the MacDowell Colony, Peterborough, New Hampshire, and creates *Lupus*, inspired by the wolf.

December, visits the West Indies island of Montserrat and is inspired by natural beauty and the ability to work outdoors.

Lectures at Harvard University, Cambridge, Massachusetts.

Gubernatorial appointment to the Massachusetts Council on the Arts and Humanities.

1984

January, creates and fabricates *Ariel*, 18 feet tall, in aircraft aluminum, his first suspended sculpture, for the Dalad Group, Independence, Ohio.

February, visits Mayan ruins in the Yucatan Peninsula.

June, exhibits at Graham Modern Gallery, New York, his first group exhibition in New York.

December, creates *Cherubim*, each 16 feet across, for Temple Emanu-El, Miami Beach, Florida.

1985

March, is commissioned by Boston developer Cabot, Cabot & Forbes to fabricate *Lupus*, 40 feet tall, for the Lotus Development Corp., Cambridge, Massachusetts.

1986

May, becomes a finalist in the national competition for Omaha Airport Authority, Omaha, Nebraska.

December, travels to Montserrat and St. Croix and begins the creation of *Dance of the Cranes*.

Creates *Dian*, in honor of the late zoologist, Dian Fossey, who studied and protected the mountain gorilla in Rwanda, Africa.

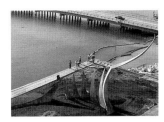

Aerial view during installation of *Aquila*, Miami, Florida, 1981

Raimondi with Grace Hartigan at her studio, Baltimore, Maryland, 1983

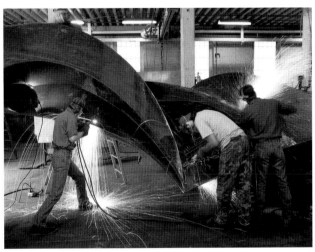

Raimondi (center) grinding sculpture, Cambridge, Massachusetts, 1985

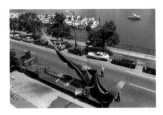

Lupus being lifted to plaza, Cambridge, Massachusetts, 1985

Raimondi working on model of *Aquila*, 1986

Raimondi as artist-in-
residence, University of
Nebraska, Kearney, *Artorius*
studies in background, 1989

Dedication of *Athleta*,
Kearney, Nebraska, 1989

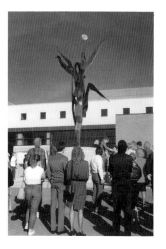

Raimondi at oceanfront
home, Palm Beach, Florida,
1990 (*Grace* in background)

1987

Spring, is commissioned by Dallas developer Lincoln
Property Company to fabricate *Aquila,* 38 feet tall by 78
by 22 feet, for Bank America (formerly Barnett Bank),
Miami, Florida.

July, moves to Palm Beach, Florida, and is awarded
commission for *Dance of the Cranes.* Nebraska
Educational Television (PBS) begins production of
a one-hour documentary film about the sculptural
process.

August, visits Venice, Sicily, and Greece and is inspired
by *Charioteer of Delphi.*

Lectures at Joslyn Art Museum, Omaha, Nebraska;
Norton Gallery of Art, West Palm Beach, Florida.

1988

Creates *Spirit Ascending* inspired by the lives of
great leaders including Dr. Martin Luther King, Jr.,
Mahatma Gandhi, and John F. Kennedy.

May, installs *Dance of the Cranes* at Eppley Airfield,
Omaha, Nebraska.

1989

Purchases and renovates an oceanfront home in
Palm Beach.

September, is awarded a national competition to create
a sculpture for a new sports coliseum at the University
of Nebraska, Kearney. Travels to Nebraska as artist-in-
residence and begins the creation of *Athleta.*

December, is commissioned by London developers
Stanhope for *Artorius,* 41 feet tall, his first European
commission. Travels throughout Europe and is inspired
by the Elgin marbles and Brancusi's Paris studio.

Lectures at ARTNews World Art Market
Conference, New York; University of Nebraska,
Kearney.

1990

Fabricates *Athleta,* 29 feet tall. Creates *Grace,* 11 feet
3 inches tall, and *Eurus,* 22 feet tall. Begins series of
tiger drawings and is elected to Defenders of Wildlife
Board of Directors, Washington, D.C.

1991

Commissioned by Admiralty Properties, Ltd., to fabricate *Dian,* 26 feet tall, for The Embassy Suites Hotel, Palm Beach Gardens, Florida. Exhibits at the Fort Lauderdale Museum of Art, Florida; O'Farrell Gallery in Brunswick, Maine; and Dolly Fiterman Fine Arts, Minneapolis, Minnesota.

1992

Creates *Bravo,* 28 feet tall, about performing arts, and *Pyre,* 18 feet tall, about the Holocaust. Exhibits *Stars in Florida* at the Fort Lauderdale Museum of Art. *Romantic Abstraction: A 20-Year Survey of Works by John Raimondi* travels to Cultural Center, Stuart, Florida; Center for the Arts, Vero Beach, Florida; and The Hyde Collection, Glens Falls, New York, his first traveling exhibit and catalogue.

Lectures at Skidmore College, Saratoga, New York.

1993

Sells oceanfront home in Palm Beach and moves to third home in Palm Beach. Creates *Sarah,* 9 feet tall, the first in a series about jazz musicians, and *Abaris,* 9 feet wide, his second mobile.

1994

Creates *Ceres,* 12 feet tall. Exhibits at the Harmon Meek Gallery in Naples, Florida.

1995

Fabricates the monumental *Spirit Ascending,* 39 feet tall, for a private collector in Manalapan, Florida. Exhibits in *Art Miami* in Miami, Florida. Creates *Tigris,* 12 feet tall, about the endangered tiger.

1996

Fabricates the monumental *Bravo,* 28 feet tall, for the Modlin Arts Center, University of Richmond, Richmond, Virginia. Exhibits *Tigris* in *Wildlife Sculpture Series III* at Cypress Gardens, Winter Park, Florida. Exhibits in *Community of Creativity: A Century of MacDowell Colony Artists,* Currier Museum of Art, Manchester, New Hampshire.

1997

The MacDowell Colony exhibit travels to the National Academy of Design, New York, and the Wichita Art Museum, Wichita, Kansas.

Creates *Journeys.*

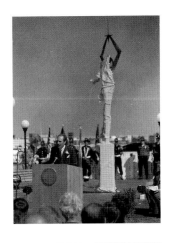

Raimondi speaking at the dedication of the Harold L. Vitale Memorial Park, Saugus, Massachusetts, 1992

Raimondi with drawings of *Bravo* and Ralph Cantin with sculpture patterns, Palm Beach, Florida, 1992

Richard Caturano, Ralph Cantin, Raimondi, and Barbara Caturano, Charlestown, Massachusetts, 1994

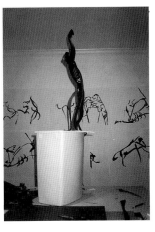

Cardboard study model and drawings for *Tigris,* 1995

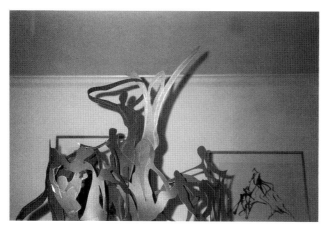
Cardboard study model for *Journeys*, 1997

1998

Begins preliminary drawings for *Chet*, about jazz musician Chet Baker. The monumental *Spirit Ascending* is donated to the Palm Beach Opera. Travels the United States to photographically document his sculptures. Is awarded an international commission for the public sculpture garden, "My Way," in Hagenbrunn, Austria, near Vienna.

Lectures at Maine College of Art, Portland.

1999

Exhibits in *Forms in Space: 20th-Century Sculpture* at the Nassau County Museum of Art, Roslyn Harbor, New York.

Purchases an apartment at Museum Tower in New York City. Fabricates *Journey* in bronze. Installs *Eurus* in Hagenbrunn, Austria.

Documentation

Selected Museum Collections

Allen Memorial Art Museum, Oberlin College,
 Oberlin, Ohio
Bass Museum of Art, Miami Beach, Florida
Butler Institute of American Art, Youngstown, Ohio
Columbus Museum of Art, Columbus, Ohio
Currier Museum of Art, Manchester, New Hampshire
Everson Museum of Art, Syracuse, New York
Honolulu Academy of Art, Honolulu, Hawaii
Milwaukee Museum of Art, Milwaukee, Wisconsin
Museum of Art, Fort Lauderdale, Florida
Museum of Fine Arts, Boston, Massachusetts
National Museum of American Art, Smithsonian
 Institution, Washington, D.C.
The Newark Museum, Newark, New Jersey
Norton Museum of Art, West Palm Beach, Florida
Oklahoma City Art Muesum, Oklahoma City,
 Oklahoma
Portland Museum of Art, Portland, Maine
Sheldon Memorial Art Gallery, Lincoln, Nebraska
Tampa Museum of Art, Tampa, Florida
Williams College Museum of Art, Williamstown,
 Massachusetts

Selected Public Collections

Arvida / J. M.B. Corporation, Boca Raton, Florida
Blue Cross/Blue Shield, Baltimore, Maryland
Blue Cross/Blue Shield, Milwaukee, Wisconsin
Cabot, Cabot & Forbes, Cambridge, Massachusetts
Canal National Bank, Portland, Maine
Centenary College, Shreveport, Louisiana
Civic League Rose Garden, San Angelo, Texas
The Colony Group, Boston, Massachusetts
The Dalad Group, Independence, Ohio
Federal Reserve Bank, Boston, Massachusetts
Glaxo Pharmaceuticals, Uxbridge, England
Metro Atlanta Chamber of Commerce,
 Atlanta, Georgia
NationsBank, Miami, Florida
NationsBank, Stuart, Florida
Northfield Mount Hermon School, Northfield,
 Massachusetts
Omaha Airport Authority, Omaha, Nebraska
Republic Security Bank, West Palm Beach, Florida
Southwest Florida International Airport,
 Fort Myers, Florida
Spaulding & Sly Corporation for IBM, Burlington,
 Massachusetts
Stanhope PLC for Stockley Park, London, England
Steelcase Corporation, Grand Rapids, Michigan
Temple Emanu-El, Miami Beach, Florida
University of Miami, Miami, Florida
University of Nebraska, Kearney, Nebraska
University of Richmond, Richmond, Virginia
University of St. Thomas, St. Paul, Minnesota
Virlane Foundation, New Orleans, Louisiana
Vitale Memorial Park, Saugus, Massachusetts

Selected Exhibitions

1999 *Forms in Space: 20th-Century Sculpture,* Nassau County Museum of Art, Roslyn Harbor, New York

1997 National Academy of Design, New York, New York
Wichita Art Museum, Wichita, Kansas

1996 *Wildlife Sculpture Series III,* Cypress Gardens, Florida
Community of Creativity: A Century of MacDowell Colony Artists, Currier Museum of Art, Manchester, New Hampshire

1995 *Art Miami,* Miami, Florida

1994 Harmon Meek Gallery, Naples, Florida

1993 Tiffany & Co., Palm Beach, Florida (solo)

1992 *Romantic Abstraction: A 20-Year Survey of Works by John Raimondi,* Traveling exhibition: Cultural Center, Stuart, Florida; Center For the Arts, Vero Beach, Florida; The Hyde Collection, Glens Falls, New York
Stars in Florida, Museum of Art, Fort Lauderdale, Florida

1991 Museum of Art, Fort Lauderdale, Florida (solo)
O'Farrell Gallery, Brunswick, Maine
Dolly Fiterman Fine Art, Minneapolis, Minnesota

1990 C. Grimaldis Gallery, Baltimore, Maryland (solo)
Michael H. Lord Gallery, Milwaukee, Wisconsin

1989 Hokin Gallery, Palm Beach, Florida (solo)
Wallace Wentworth Gallery, Washington, D.C. (solo)
Gucci, Inc., Palm Beach, Florida (solo)
Arlene McDaniel Galleries, outdoor sculptures, Simsbury, Connecticut

1988 Judith N. Wolov Gallery, Boston, Massachusetts (solo)
Dance of the Cranes: Evolutionary Drawings, Joslyn Art Museum, Omaha, Nebraska (solo)

1987 *Art against AIDS,* Graham Modern Gallery, New York, New York
87—Contemporary Sculpture at Chesterwood, Stockbridge, Massachusetts

Virginia Miller Galleries, Coral Gables, Florida (solo)

1986 *Lupus: Evolutionary Drawings,* Lotus Development Corp., Cambridge, Massachusetts (solo)
Virginia Miller Galleries, Coral Gables, Florida

1985 Tiffany & Co., Boston, Massachusetts (solo)
Academy of the Arts, Easton, Maryland

1984 McNay Art Museum, San Antonio, Texas
Graham Modern Gallery, New York, New York
Chicago Art Exposition, outdoor sculptures, Chicago, Illinois

1983 Virginia Miller Galleries, Coral Gables, Florida (solo)
Dolly Fiterman Gallery, Minneapolis, Minnesota (solo)

1982 *New Accessions,* National Museum of American Art, Washington D.C.
C. Grimaldis Gallery, Baltimore, Maryland

1981 Galerie Ninety-Nine, Bay Harbor Islands, Florida

1980 *Art for Architectural Spaces,* Arts Gallery, Baltimore, Maryland

1978 Irving Galleries, Palm Beach, Florida
Milwaukee Art Museum, Milwaukee, Wisconsin

1976 Sunne Savage Gallery, Boston, Massachusetts (solo)
Interstate 80 Sculptors, Sheldon Memorial Art Gallery, Lincoln, Nebraska

1974 Boston City Hall, Boston, Massachusetts

1973 Brockton Art Center-Fuller Memorial, Brockton, Massachusetts

1972 Boston Architectural Center, Boston, Massachusetts
Boston Center for the Arts, Boston, Massachusetts

1971 Boston City Hall, Boston, Massachusetts

1970 New England Sculptors Association, Boston University, Boston, Massachusetts

Selected Bibliography

Interviews, Books, Exhibition Catalogues, and Films

Aquila, exhibition catalogue. Text by Carl Belz. Miami: Barnett Tower Gallery, 1987.

Athleta: Drawings by John Raimondi, exhibition catalogue. Text by Mary Lierley. Kearney, Nebraska: Walker Art Gallery, 1990.

Beem, Edgar Allen. *Maine Art. Now.* Gardiner, Maine: The Dog Ear Press, 1990.

Dance of the Cranes. Public Broadcasting System. One-hour documentary film produced by Nebraska Educational Television, 1989.

Dance of the Cranes, exhibition catalogue. Text by Norman A. Geske. Omaha: Omaha Airport Authority, 1988.

Dance of the Cranes: Drawings by John Raimondi, exhibition catalogue. Text by Ellen Simak. Omaha: Joslyn Art Museum, 1988.

The Five-Hundred Mile Sculpture Garden. Nebraska Educational Television. One-hour documentary that includes a 28-minute segment about Raimondi's work *Erma's Desire,* 1976.

The Grammar of Bronze. University of Nebraska Film Department. One-half hour documentary about the creation of *Athleta,* 1990.

Janovy, John, Jr. "Erma's Desire." First chapter of the nonfiction book *Back to Keith County.* New York: St. Martins Press, 1981.

Kuralt, Charles. *Dateline America.* New York: Harcourt Brace Jovanovich, 1979.

Lupus: Evolutionary Drawings, exhibition catalogue. Text by Carl Belz. Cambridge: Lotus Development Corp. Gallery, 1986.

Michael. National Endowment for the Arts documentary film of residency in vocational high school. The film, made by Guggenheim Productions, received a New York Film Festival Award and was distributed to every arts council in the country, 1974.

Romantic Abstraction: A Twenty-Year Survey, exhibition catalogue. Text by Sherry Chayat. Stuart, Florida: Martin County Council for the Arts, 1992.

Redstone, Louis. *Public Art—New Directions.* New York: McGraw Hill, 1981.

Articles and Reviews

Ahlander, Leslie Judd. "The Eagle Has Landed." *Miami News,* May 15, 1987.

———. "Naturally Eloquent Sculpture." *Miami News,* August 26, 1983.

Allan, Tom. "*Erma* Sculptor Winning over Critics." *Omaha World-Herald,* June 16, 1976.

———. "Erma Is Home." *Omaha World-Herald,* July 4, 1976.

"America's New Leadership Class." *Esquire,* December 1985.

Armstrong, Jessica. "Monumental Metal Sculptures Seem Delicate." *Martin County Guide,* March 5, 1992.

Aude, Karen. "Making a Statement through Sculpture." *Cape Cod Life,* Summer 1984.

Auer, James. "Sculptor Creates for His Father." *Milwaukee Journal,* May 17, 1978.

B.A.R. "Portland's Michael." *Maine Times,* July 11, 1975.

Baker, Sue. "Arts Cover for Raimondi." *Winthrop Sun Transcript,* May 11, 1983.

Baltozer, Diane. "His Inspiration Comes Natural." *Patriot Ledger,* September 2, 1986.

Baumert, Harry. "Erma Arrives." *Grand Island Daily Independent,* June 26, 1976.

Beem, Edgar Allen. "Part Controversy." *Maine Times,* November 19, 1982.

Blake, Gloria. "Prolific, Passionate, and Profound." *Haut Decor International,* Number 2, 1996.

Brookmire, Paula. "Open Air Art." *Milwaukee Journal,* November 3, 1985.

Chayat, Sherry. "Metal Mettle." *Palm Beach County Arts,* April–June 1991.

———. "Jewel of a Museum Hosts Graceful Sculptures." *Syracuse Herald American,* August 23, 1992.

Clow, Gerry. "John Raimondi Makes Every Sculpture Tell a Story." *Boston Globe,* March 20, 1973.

———. "Reflections on Highway Art." *Valley Advocate,* September 19, 1973.

Cohan, Gwen. "Palm Beach Treasure." *Worth Avenue Magazine,* 1990.

Danikian, Caron LeBrun. "Abstract Art that Speaks to People." *Christian Science Monitor,* January 30, 1976.

Denney, James. "Nebraska's Sculpture Garden." *Sunday World-Herald Magazine of the Midlands,* October 23, 1977.

Design & Environment 16 (winter 1973).

Donelian, Susan. "Museums without Walls." *Palm Beach Life,* February 1984.

Dumas, Maurice. "Sculpture a Symbol of Friendship." *Finger Lakes Times,* August 9, 1979.

Dvorak, John A. "*Erma's Desire* Stirs Nebraska Art Lovers." *Kansas City Times,* July 2, 1976.

Ellingsworth, Linda. *Chronicle* (Glens Falls, New York), August 26, 1992.

Esquivel, Mary Ann. "Art, Brickell Ave. Style: The 'Eagle' Has Landed." *Miami Herald,* April 29, 1987.

Feldman, Diane. "Artist in School." *Kearney Hub* (University of Nebraska), March 30, 1990.

Fitzgerald, Vicki. "Pioneering Project Turns Trade into Art." *Patriot Ledger,* August 7, 1974.

———. "Sculpture Is Exactly What He Wants to Do." *Patriot Ledger,* September 27, 1973.

Fox, Kate Schaal. *Times Record* (Brunswick, Maine), December 6, 1974.

Gaeta, Michael. "Monumental Success." *Palm Beach Daily News,* December 23, 1990.

"Geysers of Protest for Nebraska Art." *New York Times,* July 31, 1975.

Giuliano, Mike. *Baltimore Evening Sun,* November 29, 1990.

Grand Island Daily Independent (editorial), November 18, 1975.

Guy, Sherry. "Capital Talent in Florida's Arts Capital." *Palm Beach County Arts,* July–September 1991.

Harding, Anne. "Sculptor Forges Link between Head, Heart." *Saratogian,* August 28, 1992.

Hawkins, Peter. "Larger than Life." *Palm Beach Illustrated,* November 1996.

Hill, Roger. "Sculpting Big." *Stuart News,* February 22, 1992.

Holtz-Kaye, Jane. *ArtNews,* March 1976.

Hunter, Chris. "Renowned Sculptor Contributes to Nebraska Skyline." *Palm Beach Daily News,* February 14, 1988.

Hurlburt, Roger. "Talent Shines with *Stars in Florida.*" *Sun-Sentinel,* February 16, 1992.

Isaacson, Philip. "Hard Times for the Public Sculptor." *Maine Sunday Telegram,* July 20, 1975.

Janz, William. "Sculptor Molds Father's Image." *Milwaukee Sentinel,* July 28, 1978.

Kelley, Mary Lou. "Sculptor Shines as a Teacher." *Christian Science Monitor,* June 19, 1974.

Kelly, Katie. "Can Sculpture Stand up beside Toilets?" *Village Voice,* December 1, 1975.

King, Shannon. "Sculptor Has Special Touch." *St. Paul Pioneer Press,* March 31, 1983.

Loercher, Diana. "Modern Art Meets Nebraska: A Standoff." *Christian Science Monitor,* August 15, 1975.

Lovitt-Psota, Janis. "KSC Sculptor." *Kearney Hub,* October 9, 1990.

MacMillan, Kyle. "Raimondi's Cranes." *Sunday Omaha World Herald,* May 22, 1988.

Marx, Linda. "John Raimondi." *Art Review Magazine,* Winter 1996.

———. "Artful Living in Palm Beach." *Florida Design* 6, no. 1.

———. "Raimondi's Desire." *Ocean Drive* 2, no. 12 (December 1994).

McCain, Nina. "Hidden Superstars." *Sunday Boston Globe,* April 20, 1980.

McGill, Douglas. *New York Times,* November 19, 1986.

Niss, Robert S. "The Man Who Made Michael." *Portland Press Herald,* May 24, 1975.

———. "Portland's Public Art." *Portland Press Herald,* June 26, 1975.

———. Where Are They Now?" *Maine Sunday Telegram,* January 19, 1992.

Olsen, Lise. *Sunday Journal-Star* (Lincoln, Nebraska), January 26, 1986.

Olson, Chris. "In Search of Fame and Fortune." *Grand Island Daily Independent,* November 29, 1975.

Omaha-World Herald (editorial), February 25, 1987.

Omaha-World Herald (editorial), October 11, 1989.

"Portland's *Michael.*" *Maine Times,* July 11, 1975.

"Public Art with Dignity." *New York Times,* September 7, 1975.

Rand, Harry. "Notes and Conversation: John Raimondi." *Arts Magazine,* April 1983 (cover story).

"*Ran* Takes Shape in the Rose Garden." *San Angelo Standard-Times,* May 29, 1979.

Rogers, Ann Ward. "Namesake Says Sculpture Shows Brothers' Love." *San Angelo Standard Times,* May 31, 1979.

Rybovich, Terre. "Affirming Art in an Age of Doubt." *Culture Magazine,* December 1996.

Schmahl, Allen F. "Sometimes Slow to Learn." *Grand Island Daily Independent,* July 18, 1986.

Schwan, Gary. "Identity and Form." *Palm Beach Post,* November 22, 1982.

———. "*Stephen's Summer.*" *Palm Beach Post,* October 14, 1983.

Sheridan, Lee. "Massachusetts '73 Becomes Reality with *Stephen's Summer.*" *Springfield Daily News,* August 26, 1973.

Silber, Howard. "Bronze Cranes to Dance at Eppley." *Omaha World-Herald,* February 23, 1987.

———. "Eppley's Cranes Take Wing in Bronze." *Sunday World Herald* (Omaha, Nebraska), December 6, 1987.

Spencer, Warren H. "The Great Bicentennial Sculpture War." *Ford Times,* September 1977.

Stankus, Al. "Creative Spaces." *Sunday Boston Herald,* June 28, 1987.

Steinhardt, John. *Herald* (Hobart & William Smith Colleges), May 1973.

Sunday Omaha World Herald (front page), April 1, 1990.

Taylor, Robert. "John Raimondi's Rhythmic Approach to Sculpture." *Boston Globe,* January 25, 1976.

Thomsen, Janet. "Sculpture Carries Meaning for State." *Grand Island Daily Independent,* May 29, 1988.

Transcript Telegram (Holyoke, Massachusetts), August 27, 1973.

Turner, Elisa. *Miami Herald,* June 18, 1987.

Ulrich, Linda. "Erma Sculptor." *Lincoln Journal,* July 8, 1986.

Villanueva, Ricardo. "Temple Emanu-El Commissions Sculpture." *Miami Herald,* February 18, 1985.

Wellenmeyer, Marilyn. "Boulevard to a Fuller Life." *Fortune Magazine,* October 1977.

Index

Page numbers in *italics* refer to illustrations.

Photograph Credits

The artist thanks David Zinn, Colortek, Boston, for the digital enhancing of a number of photographs. All photographs are by the artist, except as listed below.

Americolor: pages 69, 75, 80, 82, 88, 92, 100, 104, 118, 119

Harry Beaumont: pages 35, 123

Ralph Cantin: pages 57, 70, 74, 114, 125

Dean's Photography; page 103

Greg Derr, *Quincy Patriot Ledger,* page 125 bottom

Peter Hall: page 46

Warren Jagger Photography, Inc.: page 63

Maximilian Kaufmann Photograph Studio: pages 76, 110

Michel Malot: page 42

Jerry Mathiason, Minneapolis: page 80

Tamara Mischenko: page 107

Morrisey Photography: page 93

Museum of Fine Arts, Boston: page 80

Larry Sanders: page 66

Sargent Architectural Photography: page 95